THE WORTH OF ART (2)

JUDITH BENHAMOU-HUET

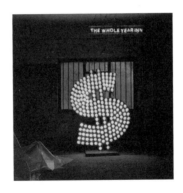

Cover:
$, Tim Noble and Sue Webster, 2001.
204 ice-white turbo reflector caps, lamps, holder, daisy washers, lacquered brass,
electronic sequencer (3 channel shimmer effect), 72'' x 48'' x 10''.
$, was shown in the exhibition of the artists' work at Gagosian Gallery, Los Angeles, in
November 2001.
It is pictured here in the empty loft that became their living and working space.

(above *$*) *The Hole You're In*,
Tim Noble and Sue Webster, 1998.
Ruby neon, Plexiglas box, sequencer, transformers,
44.5'' x 4.5'' x 3.5''.

Photo © Jonathan Becker.

© 2008 Assouline Publishing
601 West 26th Street, 18th floor
New York, NY 10001, USA
Tel.: 212 989-6810 Fax: 212 647-0005
www.assouline.com

Translated from the French by Charles Penwarden

Color separation by Gravor (Switzerland)
Printed in the United States

ISBN: 978 2 75940 147 5

THE WORTH OF ART (2)

JUDITH BENHAMOU-HUET

ASSOULINE

This limited edition was made possible by the generous support of Swarovski and the Accompanied Literary Society.

Presented on the occasion of Art Basel Miami Beach 2007.

"Works of art, which represent the highest level of spiritual production, will find favor in the eyes of the bourgeois only if they are presented as being liable to directly generate material wealth."

<div align="right">

KARL MARX,
on the notion of surplus value in
Book IV of *Capital*

</div>

CONTENTS

"At that time Dill and Cleo were living in Greenwich; they'd sold their town house on Riverview Terrace and had only a two-room pied-à-terre at the Pierre, just a living room and a bedroom. In the car, after they'd left the Cowleses', he suggested they stop by the Pierre for a nightcap: he wanted her opinion of his new Bonnard. She said she would be pleased to give her opinion; and why shouldn't the idiot have one? Wasn't her husband on the board of directors at the Modern?"

TRUMAN CAPOTE, *Answered Prayers, the Unfinished Novel,* 1988

Introduction

The art market is one of the manifestations of our new consumer society. It is, to use a word that is ordinarily applied much too indiscriminately, a postmodern phenomenon.

For the market to maximize its media profile and glamour, the following are required:

— the globalization of its effects

— a disconnect between consumption and the intrinsic nature of the product being consumed

— spectacularly arbitrary prices both for buyers and sellers

— fickle tastes

— a desire for superficiality in the approach to a field considered in principle as expressive of a certain profundity

— a culture of leisure characterized by the consumption of contemporary cultural products

— the application of social codes imported from the luxury sector

— massive participation by countries previously considered underdeveloped in this respect

— speculation around phenomena boosted by massive, if to some extent justified, interest

— the omnipresence of finance in actions of valorization

— the granting of exorbitant privileges to the very rich, who are liable to be active in the market

This book will not be about beauty (or perhaps only a little) or justice in art, or art history, but about men and women who play on vanity, marketing, dreams, snobbery, and the desperate desire to be someone.

This is not to say that justice, beauty, and art history are not an integral part of the world of art, but that today they are clearly secondary factors, even if the players on the market are skilled at using them as a commercial pitch.

In fact, the art market as we know it today is the product of a small revolution that occurred in the 1980s. This period of flourishing consumerism was when the Anglo-American auction houses decided to extend the demographic of art consumers. The number of people who are capable—for social or financial reasons, that is—of taking an interest in a blue sky by Monet, a mountain painted by Cézanne, a piece of furniture made in the eighteenth century, or an Egyptian sculpture has always been limited. The target group has always been elitist by its very essence. Anyway, back in the 1980s the art market was comprised of a few serious galleries scattered 'round the world; a certain number of renowned antiques dealers providing a personal service; the Hôtel Drouot in Paris, which had retained its prestige from the prewar years and still auctioned off major collections; and Sotheby's and Christie's, which were then still in gestation. The revolution lay in the fact that these English-American firms made the art market accessible, not only to those wealthy individuals belonging to a narrow circle of cultivated initiates, but to wealthy individuals, in general. A new relation to art was about to emerge. The foundations of the rules in effect today were being laid.

The two auction houses began to publish catalogs that you could really read, full of handsome illustrations to leaf through. Operations became society events, prestigiously framing the sales. The idea was to attract money wherever they found it, even if that meant challenging the canons of good taste. In the modern art market, there is room for everyone, for every sensibility, style, and nationality, providing

they can be backed up with cash. But the system is underwritten by people who represent either culture or good society or—and this was even more common in the 1980s—the aristocracy. It was a kind of substitute for the high society salons of the turn of the century. And also an activity for the growing leisure class, from Monaco to New York.

Today, consuming art has become a real social phenomenon, and there can be no doubt that sensibility is not always the defining characteristic of the extensive global public concerned with this practice. People also buy art for reasons that have nothing to do with art itself. There are many of these: wanting to belong to the circle of folk with their finger on the pulse; thinking that one is really on the ball when the very foundations of society are shifting (the relation to space and to time, to aesthetics, family, work, money, and inter-human communication); and the urge to make money using criteria that are less tangible than the rules of stock exchanges, freight, or commodities. It is from this growth in the number of consumers that the art market draws its strength. And it is also the very phenomenon that could lead to the collapse of part—and potentially a very large part—of the contemporary art market.

Scaling the Everest of prices
Why pay less?

What could be called the phenomenon of "price brinkmanship" originated in auction rooms, and was greatly encouraged by their attendees. One need only go to a major New York sale of modern or contemporary art—the so-called Part 1 sales, with their confetti of million-dollar tickets—to see what I mean. From the start, the operation is organized so as to draw the right crowd, a group of individuals beyond just potential buyers. In fact, the sale is a real show, albeit a show in the very best taste. The women are elegantly made-up and

dressed, the men nearly all wear ties, and the company personnel are in tuxedos. The journalists are packed together in a corner of the room. And everybody prepares to enjoy the battle that a handful of fanatics will wage with millions of greenbacks in order to win the coveted object. And as the bids escalate, so the cost is measured out, not only in dollars, but also in pounds sterling, Japanese yen, Swiss francs, and—this is new—rubles and Hong Kong dollars. The figures are all presented on an illuminated signboard behind the hammer-wielding auctioneer, in clear view of the spectators. Thus the competition is mapped out geographically as well as financially. Just before the action starts, you can always count on some drop-dead glamorous young woman sashaying across the room. We are not so far from the spirit of the Cannes Film Festival. But wait, bidding has begun. The auctioneer sets the rhythm, and the figures fly. The tension rises as bids cross the $10 and $50 million thresholds, signaled by stirrings among the public. But don't be taken in. This audience is not intelligent. It is not waiting to spot "the right price," but hoping for a financial field day. It wants a sensation, a new peak in the chain of mountainous sums. Hence the thunderous applause that greets the humongous hammer price. The spectators at the auction arena play the game. Free from critical spirit, they fan the bidders' flames, their only thought being, "more, higher!"

Theater or roulette? On May 17, 2007, an anonymous client somewhere on the globe phoned through to pay $71.7 million for a 1963 Andy Warhol painting entitled *Green Car Crash*. His identity was shrouded in mystery. The only thing known for certain was the identity of the man at the other end of the line, Ken Yeh, deputy chairman of Christie's in Asia. The next day, Carol Vogel, *The New York Times'* art market specialist, whose word is gospel for market followers, wrote: "There were some moments of pure auction theater. When the evening's star painting—Warhol's *Green Car Crash (Green Burning Car I)*, from 1963—came up, five people instantly went for it. When the bidding came down to just two telephones, Christopher Burge, the auctioneer, expertly pitted the contenders

against each other. And just as the price hit $64 million, with audience members on the edge of their seats, out of nowhere the Manhattan dealer Larry Gagosian lifted his paddle. But he didn't get the painting."

It all ended with a record price for Warhol, a work fetching $64.4 million more than the artist's previous record, a portrait of Mao sold six months earlier. In her article, Vogel sounds like the enthusiastic crowd that May 17 as she evokes "the winner at $71.7 million." So, the winner is the person who coughs up the most money. For once, not everyone would agree. After the sale, paper magnate Peter Brant, himself a big-time collector of Warhol and Basquiat, among others, acknowledged, "It's unbelievable, amazing." Then, after a pause, he added: "But there will be a day of reckoning."

Sour grapes versus the jubilation of spectators over the "winning" price...this great event in which Christie's could take such pride was netcast on its Web site for the benefit of those unlucky enough not to be there. Warhol surely would have loved to take the credit ("that really will do nicely") for this posthumous film, and to have replayed the show of rising bids: The audience growing tenser as the prices got dizzyingly steep, the pure-Brit auctioneer trying to lighten the atmosphere in this battle of the millions, the late arrival of bidder Larry Gagosian—acting on behalf of star hedge-fund investor Steve Cohen—and finally, the mysterious telephone buyer. And down goes the hammer.

The power of the media

One thing the art market has in common with terrorism is that it can function only in close collaboration with the media. What would be the point of taking hostages if television weren't there to film and broadcast the anxiety of the captives' families, the terrorists' demands, and the reactions of politicians? And what would be the point of a record price if nobody knew about it, if the billionaire's neighbor, a billionaire and collector himself, wasn't tempted to do even better next time round?

The media are also key to the credibility of the process. This begins before the sale itself, when the press is used to talk up the collections or single works and at the same time arouse the desire of potential buyers. It continues after the sale in order to echo the most impressive prices (and not, of course, disappointing ones). At the time of this writing, Christie's employed no less than thirty-four staff members around the world to manage the press. That's the way it is, and that is why, since the 1980s, works by Van Gogh and, more recently, Picasso have appeared on TV news broadcasts the world over. Note that it is the money from selling these paintings, and not the paintings themselves, that has made art such a big event. Art itself is too elitist to excite planetary interest. But money for art, that's another matter. To date, the biggest exploit, that is, the absolute record for an auction sale, is the one achieved by Sotheby's in May 2004. The work was a pink period Picasso, painted in 1905. *Boy with a Pipe* has a bewitching mystery to it. When painting this young man in his working overalls, the artist strangely elected to place a garland of flowers on his head. The reproduction of the work on the catalog cover gave precious little idea of the eroticism emanating from the youth, and Sotheby's very prim text rather avoided the question. The auction house cropped the image so as to soften its impact. In reality, the boy's posture—body thrust forward, legs well apart—is provocative, and his pants are manifestly swelled by desire.

That night in May 2004, the starting price of $55 million rose million by million as the seven bidders pushed it higher, either over the phone or through their dealers. Perhaps we will never know who bought *Boy with a Pipe* for more than $104 million. Who paid this unprecedented and unmatched price at auction without basking in the public glory as record buyer? One of the new Russian billionaires? That is the most plausible explanation. The previous record, $82.5 million for *Portrait of Dr. Gachet*, was notched up in 1990, at a time of hysterical prices for art. "This price marks the beginning of a new period of rising prices for twentieth-century art," predicted

Charles Moffett, then head of modern art at Sotheby's. He was right. And the media impact of this record sale—colossal.

But major press coverage of auctions was nothing new. On a more modest scale, in 1999, before the organization of the Lagerfeld sale at Christie's, featuring the contents of the designer's Parisian mansion, the firm's media plan set out to reach some 8.1 million readers of daily, weekly, and monthly press.

Other well-noticed events included the sale of Maria Callas's possessions in 2001, which generated two thousand articles, and the spectacular sale at the Hôtel Drouot of the contents of the Parisian studio of the great theoretician of surrealism, André Breton, which attracted fifty-thousand people into the exhibition rooms before the auction began. The proceeds exceeded all expectations: forty-one hundred lots were sold in fifty-two hours for $50.1 million.

In quality terms, however, the message put out during this kind of event is rather simplistic. Most articles simply emphasize the astronomical prices fetched by the works, or their estimated value, the name of the artist, and a few glowing descriptions echoing the press releases. By an irony of fate, the name of the auction house usually is forgotten, and ordinary folk regularly mix up the rival sisters Sotheby's and Christie's.

That being said, we should also note that, outside the big modern and contemporary sales in New York, few spectators or even clients actually attend the auctions at the big houses, the latter for reasons of discretion, the former perhaps for fear of boredom. And so these long, cascading enumerations of prices fall mainly on professional ears. In order to palliate this absence, Christie's and Sotheby's innovated in May 2007 by starting to netcast some of the key sales.

It should be noted that a number of smart operators in the buyers' camp have taken advantage of the "top-dollar" paradox. On June 5, 2007, for example, Christie's New York sold *La Maison Tropicale* (Tropical House), a building in kit form designed in 1951 by Jean Prouvé as a solution to housing problems in the African colonies. But while it originally had a social function, like all the

designs by this architect, over the years Prouvé's house had become an icon of modernity. The house belonged to Éric Touchaleaume, a Parisian dealer who tried—in vain—to sell the work in Paris by exhibiting it on the banks of the Seine near Place de la Concorde during the Paris contemporary art fair, the FIAC. In the end, this sixteen-foot-high and fifty-nine-foot-wide monument, the aluminum roof and walls of which heralded the coming wave of prefabricated buildings, was sold at auction for $4.9 million. And, contrary to current practice at auctions, the name of the happy buyer became known almost at once: It was specified in the Christie's press release that communicated the results of the sale. The man in question was André Balazs. Thus, the owner of some of the world's most glamorous hotels—Chateau Marmont in Los Angeles, the Mercer in New York, and the Raleigh in Miami—was splashing out on a shelter that can be dismantled and was originally designed for the inhabitants of Brazzaville. In fact, the lofty sum paid out by Balazs gave him the chance to attract some excellent publicity. What was the new owner going to do with the house? Put it "somewhere sunny," he stated. Linking *La Maison Tropicale* with one of his hotel programs would be an excellent communications coup. Insistent rumors say he plans to put it in the hallway of one of his establishments.

The Las Vegas–based collector Steve Wynn also knows how to make the most of his massive investments in art, but in a more systematic way. Before the 1996 sales in New York, he was completely unknown to the general public. Then, on November 12 and 13, he made several acquisitions at Sotheby's and Christie's. Wynn magnanimously agreed to let the auction houses mention his name and stated that the purchases were part of an ongoing project for his company, Mirage Resorts. A successful entrepreneur, Wynn also suffers from a chronic illness that will eventually cause him to go completely blind. Anyway, he had plans to build a new casino and hotel at Las Vegas, the Bellagio. Its distinguishing feature: it would contain masterpiece paintings. The media went for the story in a big way, and the Bellagio and its owner shot to fame before the

establishment had even opened. That is what you call an effective ad campaign.

Wynn's celebrity came, among other things, from paying $3.4 million for a 1906 Picasso painting of an arid landscape in pinkish hues, a view of Gosol in Spain. The entrepreneur apparently had no qualms about selling the work to someone else that same evening.

Today, the Bellagio no longer belongs to Steve Wynn, but the idea of having a museum in Las Vegas—and let's face it, it is a pretty surprising one—has become a reality. The Guggenheim has taken up the concept and now has a space designed by Rem Koolhaas in the city. Louis-Leopold Boilly and Picasso hang right there in the capital of frivolity and gambling. For the record, the idea of an art-money-gambling triad was conceived by Tom Krens, boss of the Guggenheim Foundation and adventurer extraordinaire in the world of museums, upon visiting the Bellagio. "People had told me about a collector who was exhibiting thirty paintings in a hotel in Las Vegas. I thought it was really stupid...In 2000 I went to Las Vegas for the first time, and I went to see the Bellagio right away. My position soon changed. The first thing that struck me when I entered the gallery was that these certainly weren't the artists' best works, but that the painters themselves were of the first rank. The second is that the gallery was full and that visitors had waited in line and paid $12 to see the paintings. And finally, the third is that they all had audio guides and were listening in religious silence. They were totally absorbed. And I thought to myself, 'What's odd about this? The idea I had before I came.' "

As for Steve Wynn, he continues to collect. Moreover, instead of the hothead, half-blind record-setter image of his early days, he is now renown for his discernment, the advantage of which is that it helps fetch higher prices when he does sell his artworks.

The Maastricht Fair is a highlight of the international antiques year. The star of the 2007 edition was one Madame Clapisson.[1] And what a charming creature she is! Sweet smile, red lips, and figure-hugging dress, she sat on a bench in the sun, surrounded by

flowers. Painted in 1882 by Auguste Renoir as an expression of bucolic joie de vivre, she appeared in the booth of one of the world leaders in modern art, the New York–based gallery Acquavella. The work belonged to Steve Wynn, who had entrusted it to his favorite "dealer." The asking price?—$45 million. The very costly portrait of Madame Clapisson, *Among the Roses*, had been purchased at an auction in 2003 for $23.5 million. So, the price had almost doubled in four years.

In business as in politics, however, over-the-top media coverage also has its risks. As Steve Wynn—again—well knows. In fall 2006, he made an unfortunate move that was broadcast all over the world. At a select social gathering, the wealthy casino owner presented a mythical Picasso painting from 1932, *Le Rêve*, (*The Dream*), representing Marie-Thérèse Walter together with an explicit erotic attribute: feminine curves and interlacing forms constituting a masculine symbol. Wynn had just sold the piece for the colossal and then unprecedented sum of $135 million to another high-profile collector, Steve Cohen, one of America's most successful hedge-fund investors. Then disaster struck. In the middle of his presentation, Wynn made a sudden gesture and put his elbow through the painting, which could now no longer be sold. Wynn himself had bought it in 1997 for $48.4 million, which meant that he stood to make a $88.4 million profit on a purchase he had held for only ten years.

One of the witnesses, Nora Ephron, was quick to describe this transformation of dream into nightmare on her blog: "He invited us to come see the painting before it moved to Connecticut, never to be seen again by anyone but people who know Steven Cohen...Wynn went on to tell us about the provenance of the painting—who'd first bought it and who'd then bought it....He raised his hand to show us something about the painting—and at that moment, his elbow crashed backwards right through the canvas...Wynn stepped away from the painting, and there, smack in the middle of Marie-Thérèse Walter's plump and allegedly erotic

forearm, was a black hole the size of a silver dollar—or, to be more exact, the size of the tip of Steve Wynn's elbow…Steve Wynn has retinitis pigmentosa, an eye disease that damages peripheral vision, but he could see quite clearly what had happened. 'Oh shit,' he said. 'Look what I've done.' The rest of us were speechless."

Is there a moral to this tale? Negotiations with the insurance company followed, along with restoration work. It may well be that the hole in the painting will soon no longer be visible—nor the one in the collector's pocket. One expert working on the case estimated the financial loss—"The damage is not in the center of the composition, but at the bottom on the right"—at 20 percent. Others believe that, contrary to expectations, *Le Rêve* could sell for even more once the damage has been repaired. The market loves such stories about famous people. Witness the fate of certain Warhol works. In 1964, a fanatical young woman turned up at the Factory and sprayed the place with her revolver, hitting a number of canvases. At the time, Warhol was working on, among other things, his series of Marilyn Monroe portraits. Twenty years later, these works appeared on the market, perfectly restored but carrying the aura of the shooting. In May 1989, a *Shot Red Marilyn* sold at auction for $4.07 million, a colossal sum in this context. In 1998, a *Shot Orange Marilyn* fetched $15.7 million from a famous collector, Condé Nast publisher S. I. Newhouse. It was the highest price yet for a Warhol.

The art market and its long history

"Art is not only the imitation of the spectacle of nature,
or the narration of a holy, fantastic, or antique story;
it is not only the writing of man's passions,
or the memory of his face. Art is also,
sometimes, a value added to works of art and their makers.
The extraordinary development of artistic 'production'
(we must deliberately use this unpleasant term) is punctuated and commentated
by a new phenomenon: the invention of a complex ensemble of texts, images,
monuments, and institutions constituting a real cortège that crowds around the
edges of artistic reality as such."

ÉDOUARD POMMIER, *Comment l'art devient l'Art dans l'Italie*
de la Renaissance,

Looking behind this media saturation the limits of which are only those of the planet itself, we find a very old reality. In all ages, works of art have been traded for cash, and lots of it, too. To this end, sophisticated systems were put in place. It is surprising to discover how long ago the principles underpinning the art market of the twenty-first century were actually conceived. Auctions have been held at least since Roman times. In those days the word was *octio*. Sales were advertised, bidding was actively encouraged, and there was speculation and prospecting for deals. The basic principles were well established. And so was international trade. The idea that "the world is one great auction house, where I buy here and put back in circulation there," which is axiomatic for the Anglo-American houses, was clearly evident in the ancient world. In Etruscan tombs—left by a civilization that dates back to the eighth century BCE in Tuscany—excavators have found ostrich eggs, Greek urns and dishes, Egyptian figurines, and amber necklaces from northern Europe. Mail order catalogs? That's nothing. Cardinal Richelieu received an album of drawings depicting the antiquities for sale in Italy, exactly like your modern

brochure. And then there is the cult of personality, which the art trade uses and abuses so flagrantly. Well, fans of Marilyn Monroe and James Bond have no claim to originality here. In the early Middle Ages, a period when, it would seem, the vigor of Christianity combined with the effects of the barbarian invasions began to undermine the notion of the artwork in favor of a souvenir industry centering on the superstar of the age, Jesus Christ. Rome was the center of a thriving trade active throughout Christendom and based on relics abundantly supplied with pickings from the tombs of the early Christians. The instruments of Christ's Passion, fragments of saints' bodies or of the clothes that had touched them all had a high exchange value.

Finally, who would be so naive as to imagine that our age invented the technique of boosting artists' status by constituting ample documentation about their work? The good old coffee-table book has some venerable ancestors. In the sixteenth century, Vasari, the compiler of *Lives of the Artists*, made a weighty contribution to establishing a hierarchy of artistic values. Matthias Waschek, at the Louvre, goes even further by showing how the now much-criticized system of peddling influence based on the triad formed by biographer, artist, and man of power is in fact a much older phenomenon. He writes: "The classic example of the 'divine' Michelangelo, of his patrons in high places and his extremely effective biographer, Giorgio Vasari, illustrates the idea that it is the artist's entourage that establishes his reputation and the reputation of his art. Although, when formulated as radically as this, this idea is perhaps excessive, we can nevertheless assume that the aura of Michelangelo's works would have been somewhat less radiant if Vasari had not written about them and if, of course, the sculptor had not worked for such an important pope as Julius II."[2] So all we have to do now is identify our modern-day Julius II, Vasari, and Michelangelo.

Art and money: an infernal couple

"It is impossible to put a value on objects such as old master paintings or rare coins, for they are unique in their field, and have no equivalent or rival...The prices attained in sales of these objects are to a large extent a matter of chance. Still, a curious mind could draw some satisfaction in a detailed study of this phenomenon."
ALFRED MARSHALL, *Principles of Economics*, 1891

A work of art is an object that has acquired an intrinsic value quite independent of its religious meaning, practical use, or weight in precious metal. A symbol of freedom. A mental disposition. A transcription of the soul. An encapsulation of all that is most noble in man.

The market is a place of economic exchange, a defined space within which supply and demand come together around everything that can be traded. Naturally, money is its absolute value, its undisputed ruler. For pure spirits free of ignominy, the coupling of art and money is abject. Art is antithetical to the market in that the latter apparently reduces something exceptional to a simple commodity. And yet an artist's work has to translate into cash value, which is why tangible criteria have very naturally emerged in an attempt to rationalize the irrational. As in most arranged marriages, the unnatural union of art and money has found a modus operandi that ensures a general equilibrium for the art-market family. And as in some arranged marriages, conflicts of interest and differences of opinion lead to abuse and other violent reactions.

Steps have therefore been taken to help rationalize the intangible by introducing different ideas about prices. In an auction there is not one price but several. These differ in accordance with the moment in the selling process. Before the auction, then, an estimate is given. This should, logically, be no more than a reflection of the observed relation of supply and demand. In practice, though, it tends to be used as a commercial strategy. In France, for example, in estate sales, it is common for the estimates to have nothing in

common with the prices on the market. The reserve price, fixed in agreement with the seller, is the amount below which a work cannot be sold. In the United States, the estimate must be equal or superior to the reserve price. The hammer price is, as its name suggests, the price at which the auctioneer brings down his hammer to clinch the sale. In France, however, one cannot be sure that the object has been sold when the gavel meets the wood. It can be withdrawn, that is, considered unsold. It is only when the results are published that the real outcome of the sale is known.

Finally, there is another unofficial price that is of vital importance in auctions. This is the guaranteed price, which is the sum that the seller will receive whatever the hammer price. This is where the purported transparency of the auction system, with the prices reflecting supply and demand, is called into question.

The aim of this book is not to study the rational criteria for establishing prices. That has been done very competently elsewhere. Let us simply remember that the price at which a work is sold is greatly influenced by its nature, by the identification and identity of its author, by its format and period, and by its degree of rarity and state of conservation.

1. The work's title is *Dans les roses (Madame Léon Clapisson)*.
2. In *Qu'est-ce qu'un chef-d'œuvre ?*, Paris: Gallimard, 2000.

The Art Lover in Belgium
A government minister, patron of arts,
ushered me 'round his home one fine day.
He watched the reaction each work did impart,
talked art and nature along the way,
then praised the landscape, explained the subject,
and above all revealed the price of each object.

Yet when we came to a portrait by Ingres
(whose puny talent forbids me to linger)
I was suddenly gripped by imperious desire
to praise J.-L. David, that imperial painter!
The gentlemen then turned to his usual broker—
standing on duty like sentry or guard,
or a valet who always faithfully prizes
his fool of a king's every solemn word—
and said, with a merchant's gleam in his eye,
"I believe, dear friend, David's on the rise!"

CHARLES BAUDELAIRE, "L'amateur des beaux-arts en Belgique,"
Les Fleurs du mal

Buyers
and prices

A. COLLECTORS IN TUNE WITH THEIR TIMES

Why so much money? What drives all these collectors to invest such vast amounts of money—as much or more than a workingman earns in a whole lifetime—in order to possess objects of intrinsic, nonmaterial value? American psychoanalyst Werner Muensterberger explored this quandary in his book *Collecting: An Unruly Passion,* in which he hints that these avidly amassed objects are like security blankets for grown-ups. "The collector, not unlike the religious believer, assigns power and value to these objects because their presence and possession seem to have a modifying—usually pleasure-giving—function in the owner's mental state."[1] There you have it: "modifying...the owner's mental state." The unconscious reasons, then, for what we might call "collector's security blankets" are manifold. For some, the idea may be that the value of the objects they buy will rub off on them. In this way, they may convince themselves that they can "be somebody." Or alternatively, they may be keen to pursue a private hobby or even to discover a different self. Regardless, it is not enough to have a tidy sum of surplus capital. To be an art addict, you also need a certain kind of moral liberty that enables you to spend lots of time and money on activities some may deem frivolous. Deep inside every rich man or woman an epic

struggle pits this moral liberty against the guilt induced by a supposed overvaluation of something impalpable: art. We can observe, too, that in times of economic crisis, guilt gains the upper hand. During a recession, some of the richest clients on the market hesitate to "splurge," even though they could easily afford it. According to Maurice Segoura, a former Parisian antiques dealer with a long history in the art trade, the target group of collectors represents a rather limited fraction of that social class known as the rich—"not many players in the economy are capable of expressing great refinement in their daily lives," he says. For Segoura, the people best equipped to join the collecting elite come from the financial sector, whereas "industrialists don't build up great collections. For them, money is not something abstract. When you ask them for a million dollars, they reply that for the same amount they could buy a factory." He backs up his assertion with a list of the eminent collectors who have marked the history of French art: Jacquemart-André, Rothschild, Camondo—bankers all.

That said, after the terrorist attack in New York in 2001, the ensuing moral and market slumps paradoxically stimulated a certain appetite for art. This reaction reflected a powerful life-affirming trend widespread in the United States: to believe in ideals, in certain absolute values, and to buy modern paintings and "serious" objects that convey a constructive image of humanity. During the auctions of May 2002, Charles Moffett, who was head of Sotheby's impressionist art department at the time, said, "new collectors have appeared on the market since the late 1990s. They are between forty and fifty years old, have a lot of money, a lot of time, and are well-advised. Even if they've suffered some major losses, their financial potential still remains enormous. They're now turning to art even more than before, considering it to be something essential to life. At the end of the day, if the stock market collapses but you've bought a sculpture by Giacometti, then at least you have something left."

So art, market, and society clearly form a united triad. To return to the psychological theories put forward by Muensterberger, "taste, choice, style are inevitably affected, albeit often unconsciously, by the

Zeitgeist, the spirit and the sociocultural climate of an era."[2] A collector is a kind of sponge who soaks up the general social mood.

Thus in the realm of contemporary art, the most emblematic shoppers—those who share an impulse to own certain artworks, and who therefore affect the prices paid for a given artist—are generally not experts. But they keep in tune with the times, they go to see museum people (usually in their home city), and above all, they employ an adviser (a profession that is growing apace with the increase in collectors themselves).

A superficial look at a certain kind of contemporary art heavily promoted by fashion trends might suggest that it is easy to get into the swing of things. Yet ever since Marcel Duchamp invented readymades and rejected "retinal" art—in other words, attractive art that produces only aesthetic pleasure—it has become necessary to acquire certain baggage. Such baggage is not a matter of mere snobbery but rather of a need to possess basic knowledge that subsequently allows your own sensibility to come into play. Some buyers hire someone else to provide the required knowledge: the notorious adviser. The demand for this occupation has outpaced its supply. There is no official diploma for art consultants, and many in search of fashionable jobs have made themselves over as such.

The new wave of buyers who want to consume but don't have the requisite skill set also created the opportunity for a powerful comeback by figurative painting, which meshes with a neophyte's idea of art: a canvas on which people, places, or things are depicted. That is how, with the aid of very skillful marketing, the Leipzig school of German art, with its grand academic tradition, has flourished on the market. The catalog to a 2005 show of new German painting at the Musée de Nîmes in France offered an analysis of the origins of this trend. "East German painting was then able to respond to a growing demand for new products, things not yet seen on the market. An art trip to the East offered a welcome change to journalists and collectors." What was involved here was not only the exotic austerity of the art of the former East Germany but also the

accessibility of works that started from the classical canons of art: canvas and paint.

Matthias Weischer is a good example of this recent painterly style. Born in 1973, he is represented by the EIGEN+ART gallery in Berlin and Leipzig. Weischer produces figurative paintings characterized by their strange atmosphere. In 2005, an entire room of the international pavilion at the Venice Biennale was devoted to the young artist's work. The Biennale event is known for drawing a crowd of connoisseurs flanked by keen consumers seeking points of reference. After the opening in Venice, the international art crowd then trooped off to Art Basel where—who would've guessed it— the few large-scale Weischer canvases on sale sold immediately, it appears, for $20,000. The following October, in London, a 2003 painting carrying a $31,000 estimate was sold at Christie's for $371,000. The rocket was primed for takeoff—and soared. Weischer had become a media figure. The watchmaker Rolex, for instance, selected him in 2004–2005 for its Mentor and Protégé Arts Initiative, a program allowing an up-and-coming artist to work with an established one, the latter being David Hockney in young Weischer's case. An account of their exchange was featured on an Internet site, under the Rolex steel crown, which also displayed Weischer's work. There was a handsome invitation to "Take a look at Matthias Weischer's paintings" and also, among other things, two pages of ads, against a green background, in the January 2006 issue of the upscale fashion mag *Vanity Fair*. For the average reader of the magazine or Web site, the fact that a firm like Rolex was banking on a young artist certainly redounded to his credit. For a young artist, keeping a cool head and maintaining artistic freedom, rather than trying to satisfy the media blitz, becomes a major challenge. At the time of this writing, things have gone well for Weischer. On May 16, 2007, Christie's sold one of his paintings, *Familie O-Mittag*, for $480,000. A new record.

The art market and acquired knowledge

To judge by hammer prices listed in the Artprice database, the more a type of work calls for thorough background knowledge, the more modest its financial success. That is the paradox of the market such as it exists today. Current buying trends—and consequently the financial primacy accorded to certain fields of collecting—are revealing of social trends and cultural preferences.

Until June 7, 2007, you had to look below the 150th ranking of highest recorded auction prices to find an antique object, in this case a Roman statue of Venus, the *Jenkins Venus*. Why? Simply because understanding and appreciating this type of work requires a certain level of artistic cultivation. It seems that it was Sheikh Abdullah Bin Mohamed Ibn Saud al-Thani, related to the emir of Qatar, who bought the statue in 2002 for the equivalent of €12.4 million, to endow a Doha museum. Since then, this Arab prince, enamored of exquisite items and therefore record prices, has encountered some rough sailing—which will be discussed later. To return to the work itself, we know that back in the eighteenth century, Jenkins, the English collector who gave the voluptuous marble statue its name, paid what was considered an uncommonly high price to take it home from Rome.

Since the 2002 sale of the Venus, a new record has been set for antiques. On June 7, 2007, Sotheby's New York sold the ninety-eight-centimeter-high bronze statue *Artemis and a Stag* for $25.5 million to an unidentified European collector. This goddess of the hunt was cast sometime between the first century BCE and the first century CE, that is to say between the end of the Hellenistic period and the beginning of the Roman empire. The work was sold by the Albright-Knox Gallery in Buffalo, New York. A leading London antiques dealer, Rupert Wace, commented, "This kind of price was to be expected. It may not be the finest antiquity to come on the market in recent years, but it is the most 'obvious.' It is big and easily understandable, with universal appeal. Very graceful, highly figurative." Universal appeal? That opinion is clearly not shared by all. The Buffalo gallery decided to unload it, along with 199 other antique pieces, in order to stock up on contemporary art.

Albright-Knox director Louis Grachos justified this decision in an official press release, calling it "a vital step toward ensuring [the gallery's] ability to build and enhance its collection of modern and contemporary art," thereby giving it the economic clout to attract regional, national, and international visitors to Buffalo.

It should be noted that not all the major patrons of Albright-Knox were in agreement with the policy of deaccessioning antiquities. One detractor of such policies includes a very high-profile curator on the American institutional scene, Michael Govan, formerly with the Dia Art Foundation and the Guggenheim in New York. He now heads a museum with encyclopedic ambitions, the Los Angeles County Museum of Art (LACMA), which is scheduled to open a new extension in February 2008. During his presentation of this new project, I questioned him about the underlying principle of expansion, which was so different from the Albright-Knox decision. He was appalled by the Buffalo museum's approach. "In the twenty-first century, we need more than ever to confront the present in the light of the past. The idea of devoting yourself to contemporary art by throwing out old items is out of date. That's what people were doing twenty-five years or so ago."

Clearly, following the social mood and keeping in tune with the times can have damaging effects.

Picasso, the ultimate benchmark

More generally, ranking works by order of the financial interest they generate would suggest that things have changed significantly, even progressively, in recent years.

The first effect has been the hike in prices for Picassos, following a reassessment of the Spanish master's relevance across all the periods of his oeuvre. He is now considered to be the greatest painter of the twentieth century, rivaled only by Matisse (as far as historians, if not the market, are concerned). The second upshot of the new attitude in the market is that the prices of nineteenth-century works, apart from exceptional items, no longer rival the astronomical prices being paid for

twentieth-century art. Another key observation is that works from the second half of the twentieth century are now reaching prices hitherto attained only by great old masters. This is a recent phenomenon—a Warhol for $71.7 million and a Rothko at $72.8 million are new numbers on the scale of monetary values.

The keenness to remain in tune with the times has also given a push to "younger" artists such as Damien Hirst (age 43) who already have a proven track record at auction. On May 16, 2007, a work from 2002 comprising a nine-foot-long metal cabinet filled with pills and other medication tripled its estimate of $2.5 million to reach $7.4 million, a record price for a Hirst. The sale catalog pointed out that *Lullaby Winter* was like a giant altar to the god of medicine and that Hirst's art had long played on the idea of improving life through pharmaceutical products. Just thirty-five days later, Sotheby's auctioned a springtime version of the series, built on the same idea and to the same dimensions (six by nine feet). *Lullaby Spring* garnered $19.2 million, the highest price ever paid at auction for a work by a living artist. Billionaire buyers from the new economy—Russian gas industrialists and Taiwanese bankers—should take note, especially since Hirst is already an old standby in the collections of businessmen such as American real-estate king Eli Broad and French luxury-goods magnate François Pinault.

Just a few years ago, the greatest trophies were expected to include blue, yellow, and green water lilies, or some plump, long-haired young woman in the countryside—decorative pieces that would look right at home in anyone's living room. It is no coincidence that today, when ranking record prices, a Roman sculpture of Venus falls far below the majority of impressionist and modern canvases, a few old masters, certain diamonds, manuscripts, and pieces of furniture. Ancient cultures are no longer as revered as they were in previous centuries. That base of learning required to understand such objects has proven a significant obstacle. The intellectual accessibility of these works also explains the disparity between the prices for modern artworks and older artworks. In order to understand an early painting, you have to recognize symbols that convey the brevity of life, or purity, or madness, or some other

theme—not the case for an impressionist sky or a bouquet of flowers, nor a Rothko composed of flat washes of pink, yellow, and white—now worth $72.8 million.

The difference in prices in these two realms is so striking that some of the more dynamic premodern galleries are using it now as an argument to attract collectors of modern art. According to Konrad Bernheimer, owner of the Bernheimer Gallery in Munich and the Colnaghi Gallery in London, several of his new customers usually buy modern art. However, one of them paid approximately €1 million at Bernheimer's stand at the antiquities fair in Maastricht for *The Matched Lovers* by Lucas Cranach the Elder. "These days a Cranach costs just a fraction of a Picasso," commented the level-headed dealer, who has just teamed up with the influential Hauser & Wirth Gallery to organize a joint show once a year: In May 2007, they hosted Old School, an event that demonstrated the link between past and present in the art of portraiture from Cranach (1472–1553) to Jeff Wall (born in 1946).

Some players qualify this new situation. Franck Giraud, a French broker working in New York who has coordinated several major sales in recent years, comments that the comparatively low prices of early modern art can be explained by the rarity of the art itself. "The problem around early modern art is now similar to the one affecting old masters. It takes a long, long time to put together a top-notch collection. By way of example, there are now less than half a dozen major paintings by Vincent Van Gogh still in private hands. Prices can go very high in modern art, but first you have to find sellers. If *Portrait of Dr. Gachet*, which sold for $82.5 million in 1990, were to be put back on sale, it might hit €130 million (about $190 million). Recently, on the private market one owner was offered €100 million for his Cézanne, while another was offered €120 million for his Van Gogh. And yet both turned the offers down."

Buyers prefer artists from their own country

In the days when he was still active in the marketplace, the famous Swiss art dealer Ernst Beyeler—who created the remarkable foundation named after him in Basel—offered a simple analysis of the art market: "There's no new behavior. Belgians buy Belgian art, Germans buy German art, Americans buy American art, and Spaniards buy Spanish art." Given recent trends to be discussed below, we might add, "and the Chinese buy Chinese art, while Russians buy Russian art." But things are not all that straightforward. If the art market were organized along national preferences so exclusively, some artists would never make a mark. Take one of the market's current stars, for example: Marlene Dumas. In February 2005, her figurative painting of children posing for a school photo (*The Teacher*) sold at Christie's in London for €2.3 million—a record for the female artist. Did her nationality as a South African help? No. Or her country of residence, the Netherlands? No, again. So the national identity claimed by an artist is not an absolute condition for market success.

Yet it can still constitute one valid argument, among others. On the international level, institutional systems still function according to principles of geographic breakdown. The most important event on the international level, of course, is the Venice Biennale because it draws the greatest number of visitors and generates the most comment. As childish as the idea of an Olympic Games of contemporary art may seem, the Biennale's exhibition policy is based on national pavilions, and it is totally accepted by the entire art community. Why should creative sensibilities be based on the artist's country of birth? That artists from countries outside the main circuit can get shown seems to be this policy's sole virtue.

Another leading, highly anticipated event on the dense international calendar is the Whitney Biennial. Who gets shown there? Only U.S. nationals or artists residing in the United States. The most recent biennial, in 2006, was co-curated by a Frenchman living in America, Philippe Vergne; currently head curator at the Walker Art Center in Minneapolis, he earned his stripes at the Musée d'Art Contemporain

in Marseille, and he rejects the principle of nationality. "I don't think the criterion [of nationality] can ever be an artistic criterion. I've always refused to organize 'flag' exhibitions. Furthermore, in a recent discussion with the artist David Hammons, he mentioned his strong desire to come up with an art free from any specific cultural identification, in order to escape all provincialism." It is nevertheless worth mentioning that the Whitney Biennial is hosted by an institution that has been devoted solely to American art since the 1920s. Originally, the millionaire Gertrude Vanderbilt Whitney funded the museum in an effort to support American talent faced with the ubiquitous presence of European art, mainly French. Yet although the United States has become the main hub of international contemporary art, the focus of the Whitney remains the same.

In recent years, the launching of two new museums made a particular splash. One was the Guggenheim Museum in Bilbao, Spain, notably known for its architecture, the other was Tate Modern, which triggered massive interest when it opened in 2000. The founding of Tate Modern meant that the original institution, the Tate Gallery, changed direction and became Tate Britain. Prior to March 2000, the museum had been devoted to all kinds of art, but from that date onward it has exhibited only British or British-based artists. So at the dawn of the twenty-first century—a time when international, intellectual, human, and economic exchanges have never been so intense— another democratic, open, and civilized country decided to devote one of its most important museums exclusively to its own art. The institution's new brief shocked no one, triggered no polemic. Nor is it a coincidence that the Turner Prize candidates are exhibited every year in Tate Britain, since the award is designed to promote the British art scene.

The priority given to national art in Britain is explicit. For example, Michael Hue-Williams—owner of the Albion, a 15,000 square foot gallery designed by Norman Foster on the banks of the Thames—explained that a particularly influential British art critic had commented that his editor would turn down reviews that were

hard to sell, that is to say, that didn't focus on British artists. "Tracy Emin, Damien Hirst, Antony Gormley, and Anish Kapoor are among the artists who will always get an article when there's something new. The public is allegedly uninterested in the rest. That partly explains the international success of the Young British Artists, which was initially due to loyal support by the local press. Everywhere in the world," continued Hue-Williams, "most collectors mainly buy works they feel are part of their own heritage. A similar phenomenon can be seen today with young German painters backed by a vast media operation. A few dealers dope journalists with information by organizing visits to museums and studios, persuading them of the importance of the new movement. At this moment, however, the biggest phenomenon [of this type] concerns China. Culture has become a major priority for the Chinese government—did you know that China had a pavilion at the Venice Biennale in 2005 for the first time? The number of potential collectors there is enormous. But when people ask me if my gallery represents Chinese artists, I say, "No, I represent *artists*." I nevertheless show a Chinese artist living in New York, Cai Guo-Qiang, who has already been shown in Venice four times. In 2005, he was the curator of China's national pavilion. For me, art is art. I try to focus all my efforts on the artists, wherever they come from."

As Hue-Williams noted, the national card has been successfully played in promoting contemporary German art. Artists from Dresden, such as Thomas Scheibitz, and from Leipzig, such as Neo Rauch, and the entire cohort of their students and followers have fueled a new trend backed by international critics and collectors from every land who are attracted not only by the return to traditional painting but also by the strong local demand. After the United States, Germany certainly represents the second-most important consumer of contemporary art. In the highest tribute possible for a contemporary artist, Neo Rauch was given a solo show at the Metropolitan Museum in New York in the summer of 2007, for which eleven new canvases were executed. Born in 1960, Rauch is

represented by the EIGEN+ART gallery in Berlin, and his output far from satisfies demand. In June 2006, one of his canvases showing an original figurative composition, similar in spirit to illustration work, was sold at auction by Sotheby's London for $844,000, a record for Rauch; in 2001 you could have bought one of his paintings for $6,000. In the intervening six years, fifty-six of his works came up for auction.

Prior to the emergence of these new schools, German painters such as Georg Baselitz and Anselm Kiefer had already enjoyed a success underpinned by strong national demand. Martin Kippenberger, meanwhile, made a notable mark on the art scene in Cologne in the 1980s and 1990s with his powerful humor, mockery, and interrogation of the rules of the art game. He never reached the top of the price rankings, but since his death in 1997 at the age of forty-four, he has been rediscovered both by artists and institutions, turning him into a solid star of the contemporary market. He has become a blue-chip investment—which would probably not be to his liking. In five years, the value of a Kippenberger has increased 266 percent according to the Artprice database. His paintings have even been subject to swift market swings: A quadriptych titled *Mit Viel Zeit* was first sold in 2003 for $140,000, only to be auctioned again in 2006 for $706,000. Major Kippenberger collectors include the influential German art publisher Benedikt Taschen, who personally knew the artist.

The current mood and economy arouse sleeping empires

German artists are not the only ones reaping the benefits of renewed national interest. And while not many people paid any attention to contemporary art from India, China, Russia, and Islamic nations ten years ago, economic and political upheavals in those countries have had a decisive impact on the value of work by local artists.

India

According to Artprice, the value of contemporary Indian art has increased by 482.72 percent in ten years. Christie's first sale of modern and contemporary Indian art was held in 2000, generating a turnover of $600,000, whereas the one held in 2006 brought in $17.8 million. One of the stars of current Indian art is Subodh Gupta (born in 1964). His distinctive sculptures incorporate items used in everyday life in India. Today his work is present at all international art fairs, but he recently told me that France was the site of his first market, thanks to Fabienne Leclerc's gallery. For that matter, wealthy French collector François Pinault owns a Gupta—a vanitas-like composition with a skull constructed of buckets and other shiny vessels, which Pinault placed in front of the Palazzo Grassi premises during the 2007 Venice Biennale. In Artprice's rankings of the turnover generated by artists, Gupta holds a very honorable eighty-third place. Yet he could still be considered a new arrival, for his works only reached auction as recently as 2005.

The gallery that represents Gupta in India, Bodhi Art, has obviously enjoyed greater international impact, yet has also encountered some unpleasant surprises: Sharmistha Ray, director of the Mumbai-based gallery, reported that Art Forum Berlin would agree to give her a stand only if she showed Gupta. Never has the art market been so shaped by assumed demand, by an identikit portrait of the ideal buyer.

So who is buying Indian art these days? The country's own newly affluent class, of course, and also members of the Indian diaspora, some of whom have never set foot in the land of their roots, but with

which they like to identify. Then there is a significant group of speculators who are betting on India's continued rise. For the latter group, Indian art, like Chinese art, looks like an investor's El Dorado—a new playing field where all dreams may come true. According to Judd Tully, a specialist reporter who writes for *Art & Auction*, the ArtsIndia Gallery in New York has opened a branch in Palo Alto, California— that is to say in Silicon Valley, home to adventurous minds, new wealth, and a substantial Indian diaspora. The gallery also organized a seminar on investing in Indian art. In London in the spring of 2007, Philip Hoffman, formerly with Christie's and now the manager of several art-investment funds, announced the creation of a new fund specializing in Indian art. "We behave like the stock market. We sell when prices are high. When it comes to contemporary art, sometimes we'll hold works for only six weeks. Our investments in this sector focus on a pool of forty artists, who are resold over a period of time." Hoffman thinks he will be able to foresee a market collapse thanks to his experts, swiftly selling his stock of art.

China

In Shanghai, Bonko Chan is considered the king of the freight business. This former Chinese air force pilot now runs an investment firm that specializes in the logistics sector. Unusually, he is familiar with modern and contemporary art not just of his own country, but also of Western lands. His view of Chinese art is merciless: "Obviously, I buy a lot of Chinese art, but I admit that, these days, much of it is for speculative reasons. I know the market very well, and although some artists will clearly survive the bubble—we have some good artists— many of them do not express anything very profound."

In Beijing, Guan Yi is one of the few major collectors of Chinese art. He currently owns some six hundred works and hopes to open a private museum. "Collecting in China has now become much more important than being an artist. All contemporary Chinese art is leaving for abroad, because all the buyers are Westerners. If your approach as a buyer is too commercial, you risk missing the art. And

if the artist's dream is the same as most Chinese, namely owning a big car, then it's too simple."

The birth of contemporary Chinese and Indian art is closely related to notions of market and price. According to Artprice, prices for avant-garde Chinese art rose 440 percent in five years. In 2006, works by Zhang Xiaogang brought in a total hammer price of $23.7 million, more than works by Jeff Koons placed on auction the same year.

And indeed, as Guan Yi pointed out, collecting Chinese art was paradoxically first done by Westerners. Uli Sigg from Switzerland, a former ambassador to Beijing as well as a former businessman, is one of the largest collectors in the field. He continues to buy and to organize promotional shows of Chinese art. As Sigg explains, "The sector is in the throes of overexcitement. There is now a large number of people in China with colossal liquidity, and they've become interested in art as a new realm of rapid profits. They like to buy known names, usually at auction." For artist Yan Pei-Ming, born in Shanghai in 1960 but now living in Burgundy, France, the local Chinese market has been overrun by speculators. "I don't want to sell there. Buyers are interested in nothing but money. It's rare to meet a real collector. Last year at Basel, one of my canvases was sold to a Chinese buyer by my French dealer, Anne de Villepoix. The buyer didn't even bother to open it once it had been wrapped. He just shipped it straight to a Christie's sale in Hong Kong." Yan Pei-Ming feels somewhat bitter about his compatriots who see contemporary art solely as a source of profit, but he nevertheless returns regularly to Shanghai to study traditional watercolor techniques. He is one of those Chinese artists who achieved recognition on the Western, mainly European, market prior to the explosion of the Chinese market. He executes powerful, often very large, portraits in an expressionist vein limited to two colors. Whereas Anne de Villepoix sold his works in 2006 for an average of €60,000 (about $69,000) each, in December of that year, Christie's Paris brought the hammer down on a 1989 black-and-white portrait of Mao at $329,000.

Leading the list of more classic artists that have appealed to non-continental admirers of Chinese art in recent years is Zao Wou-Ki.

Born in Beijing in 1921, Zao Wou-Ki arrived in Paris in 1948 and combined traditional Chinese inspiration with Western modernity in an abstract idiom. Like many French artists, for a long time Zao Wou-Ki remained unaffected by the exploding prices at international auctions. Yet, in January 2007, a large, luminous composition dated 1958 sold in Hong Kong for the record price of $3.2 million. His previous record, set in 2002, was just one-third that price.

The list of record sales and speculative buys of contemporary Chinese art is already long—the sector has given birth to such hopes among the auction houses that they now like to leaven their sales of "Western" contemporary art with a few Chinese offerings. Such is the case with Zhang Xiaogang (born in 1958), a painter first exhibited in Paris by Catherine Thieck, who ran the Galerie de France. The now-retired Thieck said, "I discovered Zhang Xiaogang in China in the early 1990s, when people in the West claimed that painting didn't exist any more. He had been trained in the Socialist Realist school, and he painted figures typical of Communist China—but the faces were altered and blemished, as though expressing the system's contradictions." Today the dealer deplores—and claims Zhang Xiaogang does, too—the speculation of which the artist has become the object. During her final appearance at the Art Basel fair in June 2006, Thieck exhibited one of his black-and-white portraits with a sale price of €150,000. Yet just three months earlier, Sotheby's New York sold a 1988 canvas, *Comrade No. 120*, for $979,000 (approximately €734,250). "Ten years ago, I had a hard time getting $10,000 to $30,000 for his work," commented the retired dealer. On November 26, 2006, *Tiananmen Square*, a 1993 painting that depicts the legendary site of Chinese culture empty with the Forbidden City—in imperial yellow—in the background, pushed record prices for Zhang Xiaogang up to $2.3 million.

The phenomenon of skyrocketing prices also affects ancient Chinese art. While the old empire's nouveaux riches are reticent about buying items that were originally placed in tombs, they are

enthusiastic about anything related to the Forbidden City, the reign of the emperors, and the local products of yore. In July 2005, a blue and white vase that would not necessarily catch a Western eye was placed on auction; however, it dates from the fourteenth century and represents a very early example of this type of porcelain. Furthermore, its decoration evokes a certain fable of a person of high rank driving a chariot drawn by a tiger and a leopard. Christie's, which described the vase as a treasure of the Yuan dynasty, valued it at roughly two million dollars. But by the time the hammer fell, the price had risen to $22.7 million.

Russia

And Russian art? Prior to the Communist era, the country enjoyed a grand tradition of collecting art. Nowadays, the return of many oligarchs to the art market has created a dizzying rise in prices. For some time, Chaim Soutine, Sonia Delaunay, and especially Marc Chagall have been well known for their avant-garde works, but the fact that they were born in Russian lands has pushed their value even higher. In 2006, no fewer than 938 lots of work by Chagall changed hands at auction. The volume of business generated by these sales attained $89 million, placing Chagall sixth among artists' rankings. Broker Lionel Pissarro says that the value of a Chagall has quadrupled in two years. While his early work was crucial to the history of art, it is clear that his later works have above all decorative interest, owing to Chagall's talent as a colorist. And yet on May 8, 2007, Sotheby's New York sold *Le Grand Cirque*, a late canvas dating from 1958, notable primarily for its size, for $13.7 million. The record price for a Chagall is nevertheless still held by a fine 1923 work delightfully titled *L'Anniversaire*, showing the artist and his wife Bella kissing in midair—it went for $14.8 million in 1990. At the time of this writing, this painting, which gave its name to a Japanese retailer specializing in wedding items, can be seen inside a fashionable outlet of the chain on Tokyo's chic shopping avenue Omote Sando.

Mathias Rastorfer, who runs the Gmurzynska gallery in Zurich, is an expert in the Russian avant-garde. He notes that when it comes to Russian buyers, "the oligarchs are no longer the only ones in the game." There is also a wealthy upper class that is seeking avant-garde artworks. Famous names such as Malevich and Rodchenko have seen their prices rise by 50 percent between 2003 and 2005. The values of lesser-known artists have increased by as much as 200 percent.

Contributing to this rise are collectors such as Andre Ruzhnikov, an American of Russian stock, who launched an art investment fund, Aurora, in April 2005. Based in New York and Moscow, the fund specializes in massive purchases of Russian works. Ruzhnikov partnered with two businessmen whose names he prefers not to divulge, but who are alleged to be Viktor Vekselberg (94th on *Forbes* 2004 list of richest people in the world) and Vladimir Voronchenko (the owner of a Russian chain of perfume shops). It is easy to imagine that this buying power inevitably accelerates the upward trend in prices. "We have an initial capital of $100 million, and we aim to buy the best Russian art," explains Aurora's director.

Russians also buy art that belongs very much to an internal market. A wonderful example is Ivan Konstantinovich Aivazovsky (1817–1900), whose prices have reached spectacular levels in recent years. This nineteenth-century painter is as academic as they come, and he specialized in seascapes with skillful effects of light. When, in 2004, a record two million dollars was paid in London for one of his works, lovers of classic Russian painting were thrilled—the painting in question showed Saint Petersburg's Saint Isaac Cathedral covered in snow. Since one record leads to another, several new "top" prices followed, until a painting of a traditional sailboat on the Dniepr River attained $3.2 million on the last day of May 2006. "Every collector of Russian art now begins with the purchase of an Aivazovsky. It's the first rung on the social ladder," explains Christie's expert Alexis de Tiesenhausen. "Aivazovsky painted rapidly and produced a lot of work. He incarnates Russian classicism."

For Petr Aven, president of Russia's premier private bank, Alfa (as well as former minister of the economy and currently the country's sixteenth largest fortune, according to *Forbes*), Russian art represents a real opportunity. "I live here. It's my culture. I know the roots behind this art. Moreover, I don't understand Western art as well. You should always start with what is most familiar. In Moscow in 1994," he continues, "you obviously found a lot more Russian art than anything else. And my choices are also a question of price. The Russian avant-gardes are still distinctly undervalued when compared to Western art of the same period. And that will continue to be the case for several years to come. Just look at any expressionist-style Russian artist compared to German artists of the same genre. A work by Max Beckman or Ernst Ludwig Kirchner will go for ten to twenty million dollars. A work of equal quality by a Russian artist such as Aristarkh Lentulov can be had for one million dollars."

Pavel Teplukhin, president of Russia's leading hedge-fund investment bank, is a recent collector who says that, for the moment, he is only able to appreciate Russian art. "Many of my clients are art lovers. In fact they're the same as the ones at Sotheby's and Christie's." He organizes guided visits of preauction exhibitions for them, and even came up with the idea of a corporate Christmas gift in the form of a lavish catalog of modern Russian artworks, all held in private collections. "It's hard to find a gift that can interest someone like [Roman] Abramovich," he says. "Normally, none of these works are on public view. He'll remember this Christmas present."

The steady rise of Islamic art

For several years, the art market was rife with stories of Sheikh al-Thani, known to dealers as "Saud," the Arab prince who was a megabuyer, a breaker of records. In Geneva, he was the record purchaser of a wristwatch, namely a 1922 Patek Philippe for which he paid 2.9 million Swiss francs. In London, he carried off a Gustave Le Gray photograph for €718,000, and in London again he caused a

stir by paying €2.3 million for a sixteenth-century Tabriz carpet. More recently, he bought the famous *Jenkins Venus* in 2002 for £7.9 million, and in 2004, he paid £3 million for a Mughal flask of jade, rubies, and emeralds. Moreover, his purchases have been particularly remarkable in the field of Islamic art. But in 2005, this relative of the emir of Qatar found himself under legal investigation, and apparently spent time in jail, accused of having confused his personal finances with those of the state. He has since been released and was seen in Maastricht in 2007 at the biggest international antiques fair, where he made new purchases. Meanwhile, the museum he has planned for his collection—apparently convincing the Chinese-American architect I. M. Pei to come out of retirement to design it—is slated to open in March 2008.

This hyperactivity of a single man from the Gulf region sparked distinct competition. There is no doubt that a competitive market for Islamic and pre-Islamic objects now exists in this region of the world. One forerunner to the crush was the brother of the emir of Kuwait, Sheikh Nasser al-Sabah, who since 1976 has overseen a collection of thirty thousand objects that cover the vast domain of Islamic art between the eighth and nineteenth centuries. Hussah al-Sabah, wife of the collector and head of the Kuwait National Museum, says that "although he owns a smaller number of works, this ensemble is comparable to the Islamic collections in the British Museum, the Louvre, and the Hermitage in Saint Petersburg."

The plan in Abu Dhabi, United Arab Emirates, is to open a "universal" museum, in collaboration with the Louvre, sometime around 2012. The establishment of this permanent collection, built on an unlimited budget, will also have an impact on rising prices in the medium term. At the same time, emblematic Western museums, such as the Victoria & Albert in London, the Louvre in Paris (whose Islamic art wing should open in 2010, thanks to €5 million in grants from both the Sultanate of Oman and the Emirate of Kuwait), and the Metropolitan Museum in New York, are all redeploying their collections and are keen to acquire new pieces. As

Sabiha al-Khemir, curator in chief of the future Museum of Islamic Arts in Doha, Qatar, explains, "After political and geopolitical developments around the world in recent years, there is a need to see, understand, and depict this culture in a different way."

More concretely, Annie Kevorkian, a Paris-based dealer and specialist in Islamic art, comments, "In the area of upper-end Islamic art and certain segments of Oriental archaeology, prices have risen fivefold in the past five years." In December 2006, the Drouot auction house presented a Sumerian statuette of a praying woman, carved in alabaster around 3,000 BCE. It fetched a record price, for its category, of €605,300. The bidders included a French museum, an American museum and, it is said, a museum from the Emirates, the presumed winning bidder.

When leafing through the catalog of the collection of the Museum of Islamic Arts in Doha, you come across a large white plate that dates from the tenth century yet looks very "modern" in design. It is inscribed with angular Kufic script, the Arabic writing used up to the fourth century of the Hegira: "Whoever misses an opportunity and then complains about fate is a fool." This proverb, more than ten centuries old, remains thoroughly up-to-date. A major civilization has long been overlooked, even by the people living in the regions concerned. A renewal of interest at the local and international levels is perfectly legitimate in an age of the hypervalorization of art.

B. LITTLE TALES OF BIG BUYERS

Art-market players divide, rather absurdly, the world of collectors into two absolutely distinct and separate camps: buyers and sellers. Since the situation is such that the number of quality pieces in circulation is constantly diminishing (new museums being one cause), sellers and potential sellers get the red-carpet treatment. They are the pampered children of the art world's financial playground.

Yet this is an area where buyers are the real source of prosperity. With their marked tastes, personalities, and intimacy with the worlds of power, fashion, museums, dealers, and auctions, these enlightened connoisseurs—these collectors in the social limelight—are what really drive this unique form of consumption. To put it more prosaically, these individuals have the power to drive prices up or down. When a socially prominent figure expresses a marked taste for a certain kind of object, he or she brings along a bevy of new consumers. In fact, the trend in today's art market could be summed up in the adage, "I am what I buy."

The new lifestyle in contemporary art

The scene takes place in Paris in 2005, during the opening of an exhibition at the Pompidou Center, but it could well have occurred in London or New York. It is 9:00 p.m., and many contemporary-art lovers are still standing in line to get into the Dionysiac show, advertised as the most iconoclastic event of the day. The line is much longer than usual. Many foreigners have come to Paris to be part of this month's key European event—the most "in" things in international contemporary art have been brought together in a show the likes of which are rarely seen in Paris. Vast installations promise pleasure, debauchery, outrageousness, consumerism, and even absurdity, all devised by artists high in demand. One of the pieces consists of the frozen souvenirs of a party: Several days earlier, artist Christophe Büchel held the party in a container within the museum itself. In this limited space, some very special guests drank, danced, and listened to

music throughout the night. The party leftovers were frozen in ice. That's what the artist had now put on show. The entire operation was organized by curator Christine Macel. While the show basically adopts a critical stance vis-à-vis society, its subject matter echoes the new lifestyle advocated by fans of contemporary art: parties, dinners, travel, and so forth.

Alison Gingeras, now exhibition curator for the Pinault Foundation in Venice, also once organized shows of contemporary art for the Pompidou Center. While working there in September 2003, at the instigation of her boyfriend, the fashionable Polish artist Piotr Uklanski, she agreed to allow a close-up of her buttocks to be spread across two pages of the American art magazine *Artforum*. The double-page spread, purchased by Uklanski himself, was apparently designed to break certain taboos. This fulsome image was accompanied by text that said, among other things, "Money buys visibility. Visibility caters to the ego." In a less provocative form, this latter sentence could serve as the slogan for the current art world. In the past several years, a kind of club has been formed of contemporary art lovers without borders. Membership rules are simple: You need lots of money; you travel; you dress well; you act cool; you're interested in the latest thing in art, with no preconceived ideas and no inclination to say, "I could have done that myself." Many businessmen and independently wealthy types, from São Paulo to Zurich via Paris and New York, henceforth follow a jet-set circuit that takes them from art fair to art fair, from biennial of contemporary art to museum exhibition to gala opening to highly select reception. Alain Servais, age forty-five, is an independent financial consultant in Brussels. He looks dapper, travels a lot, and lives in a nine-thousand-square-foot loft in a former factory, which he has conscientiously filled with contemporary art. "Contemporary art has changed my life. It not only helps you to know yourself better, it brings a festive touch to your life. Last year I attended eleven fairs, I visited collections, I met artists. It was delightful. We're living in an amazingly open-minded world."

Ignacio Liprandi, a handsome man of forty and a former vice president at Merrill Lynch (Argentina and Uruguay), acquired a passion for contemporary art following a divorce. "Berlin, Turin, Athens, London, Miami, Basel, and especially the Venice Biennale—it's an all-consuming passion. And we're treated like spoiled children, invited everywhere to see private collections and attend cocktail parties. So it's also a way to meet people and to travel. In short, a lifestyle."

The organizers of art fairs now shrewdly offer packages aimed at their VIP clients. Katelijne De Becker, who runs the Armory Show (the largest event of its kind in New York, held every March), explains, for example, that her job "involves offering collectors the best of New York." She thus organizes visits to private collections for upscale buyers. "We manage to get into private homes to show how people live with art on a day-to-day basis. At first, we had to go directly to collectors and ask, but now they come to us, asking us to include their apartment in the tour." London also has a very trendy art fair in October which draws many art lovers across the Atlantic. Why? Because it's organized by the editors of an "in" magazine, *Frieze,* and is held in Europe's hottest city—the nightlife for fairgoers is an endless rounds of clubs and restaurants that flaunt Britain's famous eccentricity. However, the most spectacular success in this vein is Art Basel Miami Beach, which has been held in Florida since 2002. The combination of luxury tourism, lavish sunshine, and shopping for upscale art swiftly proved a winner. The center of action during the four-day marketing event is the romantic Delano Hotel, designed by Philippe Starck in Miami's art deco district. Opposite an exotic park, an army of maître d's in white Bermudas welcome jet-set visitors in search of the night's best party. Access is carefully regulated here: a VIP invitation will suffice for a reception thrown by the art publisher Taschen, but after midnight getting to the bar of a swinging little party laid out in the hotel gardens will require a "super-VIP" invitation, accorded to a select few. (One event, sponsored by a brand of alcoholic drink, featured the distribution of thongs to all the ladies.)

So where's the art in all that? During the day, this swarm of VIPs visits fine homes and private exhibition spaces belonging to the wealthy in local hotel and agribusiness industries, who are moreover massive collectors of cutting-edge contemporary art. "Buying contemporary art is the ultimate lifestyle choice," explains Lorenzo Rudolf, who was behind the Art Basel Miami Beach fair and, in collaboration with Swiss dealer Pierre Huber, has launched a new contemporary art fair in Shanghai, held for the first time in September 2007. "At the moment," he continues, "the international elite is not composed of people with the knowledge [of art] but of people with the money and a certain taste that can be expressed through art. Collecting is like earning a merit badge in contemporary lifestyle."

The most fashionable event nevertheless remains the launch of the Venice Biennale in June. Rudolf says, "People don't go to Venice to look at contemporary art but to see and be seen. Palazzos, private parties, it's the perfect venue for contemporary art's new lifestyle." All the members of this elite club then meet again the following week to go shopping at the Art Basel fair.

Avant-garde taste dictated by a little old lady

Though the art in question is contemporary, the tastemakers need not be young. And although the following tale is now a few years old, it remains archetypal. It's the story of Elaine Dannheisser, a woman once known for her sharp eye, her power to influence, and upon her death, her will's generous treatment of her dog (which many humans would envy).

The scene takes place on Park Avenue, New York, on a December afternoon in the late 1990s. On the top floor of a luxurious building, an old woman lies in her bed. The doorman calls up to announce a visitor—who will therefore find the apartment door open. Upon entering the apartment, the visitor is greeted by a canine reception committee. A hysterical little dog yaps out its welcome. To meet Elaine Dannheisser you have to go to her bedroom. There, above the old

lady's head, watching over her sleep, is Robert Mapplethorpe's black-and-white photographic portrait of Elaine and her late husband. The dog goes on barking and jumping, obviously anxious to monopolize the visitor's attention. But its owner seems physically very weary. One eye half-closed, her night apparel slightly out of place. And it is only six in the evening. Who would guess that this is one of the gurus of American contemporary art, and therefore of contemporary art worldwide? However, when Elaine Dannheisser gets talking about current art, the energy she exudes seems to increase exponentially as, from the depths of her bed, she makes and unmakes the art world, drawing from her store of knowledge and memory. Dannheisser fears no one and pulls no punches. She describes one of her first "highly visible" acquisitions. "It was in 1987 or 1988. I had bought a Bruce Nauman piece at auction for about $450,000. That day I was with a friend from Chicago who said, 'Now you have art-world credibility.' In the past I used to go around the galleries every Saturday, buying things…I made lots of mistakes, too. I remember once the rumor went around—and it was true—that I had bought a piece by Sue Williams at 303 Gallery. After my visit, they sold everything they had." And she adds, "I like to watch artists develop. But that doesn't change my life. It just makes it more interesting."

A few years before her death, Dannheisser resigned from the board of the Guggenheim Museum in New York after a stormy spat with Tom Krens, the institution's very media-friendly director. She had given them a Rothko, *Purple Red*, the one shown on the catalog cover of the Whitney retrospective, and a Rauschenberg. But Krens "didn't pay any attention. He only goes with the big. The very big." Since 1996 she had sat on the board of trustees of the Museum of Modern Art, an honor that she repaid in 1998 by donating eighty-five artworks. This act of generosity was officially acknowledged as "one of the largest and most significant gifts of art in the Museum of Modern Art's history." The donation was celebrated in the exhibition On the Edge. This vast, eclectic hoard included sculptures by the minimalist artists Carl Andre and Richard Serra, austere abstractions

by Brice Marden, and white paintings by Robert Ryman. More significantly, the donation also encompassed works by Cindy Sherman, Felix Gonzalez-Torres, Matthew Barney, Jeff Koons, and Robert Gober. This was where Dannheisser really made an impact. Her early, radical choices favored avant-garde video art, drawings, installations, and photos. The artists she invested in are now all stars of the contemporary art scene—and the market. The curator of On the Edge, Robert Storr, observed that "the Dannheisser collection provides a detailed and discerning overview of some of the best and most provocative work produced in our day." Storr has since left MoMA but continues to make an impact on the contemporary scene, having curated the latest Venice Biennale in 2007.

These days, dealers and curators say—in whispers, or almost—that MoMA has become an institution that no longer takes artistic risks. Many of the artists shown there are already on the hit parade of established figures, and the museum's commercial success is due to the personality of its director, Glenn Lowry, who has a politician's sense of popular appeal. It seems the pioneering spirit of discovery is no longer on the agenda.

Saatchi, a collector of collections

This time, our setting is London in the 1980s. The theme is a success story with a strong British cast. In the role of creative leader is Damien Hirst, an artist with a supreme gift for self-promotion that makes him a worthy heir of Warhol. Jay Jopling plays the role of the dealer with a nose for the next, new thing. And Charles Saatchi, emblematic advertising exec of the Thatcher era, takes on that of the fanatical collector. Backing up this trio, in the guest-star spot, we have a prestigious institution, the Tate Gallery.

In London, like everywhere else at the time, the local art scene struggles under the weight of American domination. Still, one art school, Goldsmiths College, is ready to hold its own. And one of its most active students is a young man from Bristol who has only just

turned twenty: Damien Hirst. To bring his studies to a fitting end, Hirst organizes a group exhibition, Freeze, in a studio in London's old working-class quarter, the East End. The show gets a lot of press attention. Here are some young artists who are breaking with the classic discourse on art, turning their attention to the anxieties of modern society: violence, sex, and death. "They seemed to come straight out of the punk era," recalls Virginia Button, a curator at the Tate Gallery. The saga is about to begin.

In 1990, Damien Hirst created *A Thousand Years,* an installation in the form of a huge glass box into which sensitive souls would be well advised not to look. It contained a swarm of flies buzzing around a decomposing cow's head. According to Hirst, the message was that by eating the carrion the flies were reintegrating it into the life cycle. A lesson on the workings of life, you might say. It certainly convinced Charles Saatchi, who bought the piece at once. Himself something of a star in Britain, Saatchi's chief claim to fame was to have helped Margaret Thatcher into Downing Street with his 1979 campaign ads showing unemployment lines and warning that "Labour [the party in power] isn't working."

But apart from his knack for devastating slogans, Saatchi was a great art lover, constantly buying minimal art and also Italian paintings and the big names of postwar American art. In 1985, he began exhibiting his collection in the spacious Saatchi Gallery, located on Boundary Road in a residential quarter of London. Saatchi and Hirst hit it off, and the adman was soon hooked into the network of Goldsmiths artists. In 1992, he put on a show of their work at his space. Simply and effectively entitled Young British Artists (YBAs), the exhibition came across as a manifesto.

Other elements came together. As Saatchi and Hirst joined forces, a talented young gallery owner, Jay Jopling, was making his debut. This young man was from the same generation as the YBAs he was about to promote—although, as a former prep-school boy, not necessarily from the same kind of background. The final element in the equation debuted in London in 1984. The Tate Gallery launched the

Turner Prize to honor the most promising new artistic talent in Britain. The event enjoyed outstanding media coverage. Not only were the nominated artists exhibited in the museum's Millbank premises but also the award ceremony was broadcast on prime-time TV. Visitors came (and still come) from all over the world to admire the new glories in the Tate Gallery.

A good number of the Turner Prize nominees or winners in the years that followed were also part of the "YBA club" promoted by its so-called patron, Charles Saatchi. The winner of the 1993 Turner Prize was Rachel Whiteread, a sculptor who made a name for herself with her casts of objects, including, most spectacularly, of an entire housing block in the East End that had been slated for demolition. Whiteread was a YBA. Then in 1995 Hirst himself won the prize, attracting unprecedented crowds with his *Mother and Child*, which consisted of a cow and calf each placed in large glass tanks filled with formaldehyde. The animals were cut in two, so that one could see their dissected innards.

YBA winners also boast Chris Ofili, a painter who happens to use elephant dung as part of his works; Sam Taylor Wood, a photographer and the wife of Jay Jopling; and Gary Hume, a painter with a penchant for portraits whose work evokes the heritage of pop art.

International exhibitions followed. The big American museums, the Venice Biennale and, above all, a highly efficient network of galleries in the United States, Switzerland, and Germany started pushing up prices for these new darlings of the avant-garde. As for Saatchi, he sold off his shares in the advertising agency he had founded with his brother and began devoting even more time to contemporary art. In 1998, he pulled off a real coup when his YBA-dominated collection was exhibited at the very respectable Royal Academy, London, under the title Sensation. Which is exactly what this much-hyped show was. The former adman's protégés scandalized and shocked the public—so the crowds flocked in.

A few months later, Saatchi sold part of his collection at Christie's. The 130 works fetched £1.6 million, double the estimate. During the sale, the selection shown at the Royal Academy was being exhibited at

Berlin's biggest venue for contemporary art, the Hamburger Bahnhof. Then, in October 1999, the Brooklyn Museum of Art, best known for its fine collections of Egyptian art and modest number of visitors, decided to host the Saatchi Collection. There, New York mayor Rudolph Giuliani was publicly shocked by the presence of elephant dung in Chris Ofili's painting of the Virgin Mary. More scandal, more publicity.

And so the saga continued. In April 2000, Charles Saatchi inaugurated And Noise, a new exhibition in his Boundary Road gallery featuring ten of his protégés, including Hirst, of course, but also Whiteread and Ofili. Saatchi himself was acclaimed the "most active collector in England since King Charles I" by a long article in the highly respected *New York Times Magazine.* Asked what drove him to collect, the patron answered: "I often ask myself the same question. I do it for the pleasure of putting on shows. The whole thing is purely selfish. It's for my personal gratification."

Today all that is ancient history. Jay Jopling henceforth represents thoroughly established artists such as Anselm Kiefer, the German artist who lives in France. Damien Hirst, meanwhile, continues to display marketing savvy in addition to remaining a high-profile artist. In 2004, he sold the contents of his restaurant, Pharmacy, for $20 million by auctioning off doors, stools, and furnishings that apparently no longer delighted customers. In 2006, Hirst exhibited his own collection of art at the Serpentine Gallery, revealing that one of his many enthusiasms included fake Picassos. Hirst is extremely talented at setting the pace: It would seem that a new taste for fakes is spreading, and Hirst's extensive buying has pushed prices for forged Picassos higher. As for Charles Saatchi, he has discovered new charms in the professional collector's life by revamping his artistic choices. The United Kingdom's second-largest art collector—after Her Majesty the Queen—has become a living legend. He is now married to Britain's sexy TV gourmet, Nigella Lawson. But he keeps his head down: He isn't seen much, he doesn't write any introductions for his catalogs, and he grants few interviews. He still skillfully works the strings of his absorbing hobby of discovering and promoting contemporary art. Saatchi incarnates the myth of the art

business all by himself. The comment most commonly made about him is that he is a speculator who scoops up artists and then drops them back into the art-market jungle. Saatchi simply says, "I don't buy art in order to leave a trace, so that people will remember me. Seeking immortality is of no interest to any sane-minded person." His goal is different because Saatchi, in fact, is not a collector of the usual things—he's a collector of collections. By studying his behavior, we realize that the principle is always the same. If he likes a movement, or any type of art from a given period, genre, or country, he will buy it massively, usually before anyone else, at low cost. Then, he promotes the artist through his influential network of museums, art galleries, auction houses, and obviously, fellow collectors. To add weight to his choices, he also publishes lavish, scholarly catalogs to accompany spectacular exhibitions. Finally, though perhaps much later, he will rid himself of earlier deeds and memories. Out with the old collection (or perhaps only certain artists in it), in with the new.

The culmination of Saatchi's glory came in the spring of 2003 when he opened new premises—since relinquished—in the vast former London County Hall on the south bank of the Thames. There he showed, for their final appearance in his stable, Young British Artists. But the former advertising executive doesn't like to repeat himself. In 2005, the "human Hoover" who vacuumed up contemporary art, as *The New York Times* described him, adopted a new battle cry: young American, Chinese, etc., artists. The lucky winners include Marlene Dumas, a South African artist living in the Netherlands. At the time of this writing, her prices are still on the rise—as mentioned earlier, one of her paintings fetched $3.3 million in February 2005. It is likely that this price was reached thanks to a prior purchase by Saatchi, in 2004, of a red monochrome portrait of a young man for the then-spectacular price of $1.2 million. Saatchi's current preoccupation, meanwhile, is the promotion of his Internet site, a platform for his own contemporary artists, as well as for those outside his purview. It's as though he wants to extend his patronage to them all, good and bad. A perfect promotional device. The new Saatchi Gallery in Chelsea, West London, will open in February 2008.

Discreet but efficient

Some art lovers are constantly in the art-market limelight yet para-
doxically cultivate a certain discretion. Such is the case of Ronald
Lauder, who for fifteen years presided over MoMA's board of trustees
and is also the owner of one of New York's more recent museums, the
Neue Galerie, which opened in 2001 and specializes in German and
Austrian art. Coheir of the cosmetic empire that bears his mother's
name, Estée Lauder, he recently reminded people of his existence by
revealing that he paid $135 million for a Gustav Klimt painting. The
symbolic import of such a purchase, which outstripped the latest auc-
tion record (even though the sum is not official, as it was for the
$104.1 million paid for Picasso's *Boy with a Pipe* at Sotheby's in 2004),
was a perfect example of art-world leadership.

The situation transpired thus: On announcing the Klimt purchase,
Lauder stated that he paid more than the price of the Picasso; people
familiar with the deal leaked the exact sum to the American press—
$135 million. The Klimt portrait, painted and gilded with gold leaf in
1907, had previously hung on the walls of the famous Belvedere
Museum in Vienna. Lauder declared that the painting "is our *Mona
Lisa*, a once-in-a-lifetime buy." Seized from the Bloch-Bauer family
by the Nazis during the Second World War, it was finally restored to
the ninety-year-old heiress, the sitter's niece, just some months
before. By agreeing to spend this sum—colossal even for a billio-
naire—in a private transaction, Lauder largely helped to push the
Austrian artist's rating all the higher.

The Klimt is now on show in the Neue Gallery, and the announ-
cement of the record sum of $135 million has drawn crowds to the
little museum on 86th Street. It is hard not to avoid establishing a hie-
rarchy of art based on a hierarchy of prices, which means that for
Lauder—an expert in art history who also collects cubist works,
among others—Klimt is more important than Picasso. Unless, of
course, personal considerations on the part of this former U.S. ambas-
sador to Austria increased his desire for this canvas. Whatever the
case, at Christie's on November 8, 2006, the Bloch-Bauer heiress,

Maria Altmann, sold other Klimts that the Austrian authorities had restored to her—ones that had been exhibited at Lauder's Neue Galerie over the summer. The hammer prices were spectacular, thanks not only to the rarity, provenance, and importance of the paintings, but also to the prior actions of America's well-known collector of modern art. Following the sale, each of these canvases topped the charts of highest prices ever paid at auction for Klimts: a 1912 portrait of the same sitter, Adèle, went for $87.9 million (estimate: $12 million); a 1903 *Birch Forest*, $40.3 million (estimate: $20 million), and so on, four times over. The previous record for a Klimt, set in 2003, had been $29 million, although it is nevertheless worth mentioning that Klimts very rarely come up for auction.

The other new star buyer, one who validates some of the astronomical prices on the contemporary-art market, is Steve Cohen. Head of SAC Capital Investors, he has been called the most powerful trader on Wall Street by *Business Week*. He obviously decided to devote part of his income to recent artworks, which is how he spent eight million dollars in a private deal for a spectacular piece by Hirst, a shark preserved in formaldehyde in a large transparent tank. Just two years ago—the transaction occurred in 2005—that price seemed exorbitant. "At the time, everyone said that investing so much in a contemporary artwork was madness," said broker Franck Giraud. "These days, it's practically a bargain compared to other prices paid for works by less important artists." The seller was none other than Charles Saatchi.

Unlike other collectors, Cohen is a discreet man. He began by buying post-impressionist and modern works. And since the group of giga-collectors is ultimately rather limited, it was Steve Wynn, who sold him two major paintings in recent years—a 1902 Gauguin and an 1890 Van Gogh, for $50 million apiece. Also featured in Cohen's collection is a painting by American artist Willem de Kooning, from his highly prized *Woman* series, which Cohen bought in 2006 for $110 million. The seller was millionaire collector David Geffen, cofounder of the Dreamworks film production company. For the record, this work had come from a museum in Tehran—being the highlight of a

fine collection of international art—which sold it to acquire an Islamic manuscript. Finally, highlights of the Cohen collection also include a Warhol *Light Blue Marilyn* apparently priced—in a private deal—at $80 million. It had a similarly glamorous provenance, having belonged to Stefan T. Edlis of Chicago, a prestigious name in the American collecting world.

The current period is unusual in being spearheaded by a set of new collectors who are in search of works of prime importance, ones known as "trophies": large, unimpeachable artworks with pedigrees and references and perfectly exemplary of the work of artists already considered to be major figures in the history of art. If Cohen started the ball rolling by collecting first modern and then contemporary art, he was followed by numerous hedge-fund investors who applied their own operating rules to the art market. As Franco-American broker Philippe Ségalot explains, "Among the new collectors the principle of buying then rapidly reselling is something completely natural. Decisions are made in a flash, as in the financial markets. It is no longer a question, as it was in the grand tradition of collecting, of keeping a work for decades. All these people—like David Ganek, one of the pioneers—'market-oriented.'"

This new buying power brings significant weight to bear on the market. To such an extent that during the Armory Show of 2007, for instance, the private art-market letter published by Baer Fax queried the drawing power of New York's contemporary art fair by pointing out that hedge-fund managers had not shown up for the opening. Also worth noting, as an indicator of the buyers' professional milieu, is the fact that in April 2007 the powerful Gagosian Gallery chose the front page of London's *Financial Times* to advertise its forthcoming New York show of work by its star artist, Takashi Murakami.

All the new fortunes made from finance, like those from new technology, share one somewhat unusual feature for capitalist society: they are in young hands. And, naturally, most of these under-forty millionaires are interested in the art of their day, thereby adding greater pressure to the rise of prices of contemporary art.

Museums buy, prices rise

But twentieth-century art is not the only field where buyers wield social influence. Among lovers of fine antiques, the most striking anecdote on this theme of "I buy therefore prices rise" concerns the Miho Museum collection and the years 1991–1998. Hiroki Koyama, a rich Osaka heiress and leader of the Shumei Family religious congregation, decided that she wanted to have a museum built by the American architect I. M. Pei, famous for his Grand Louvre pyramid to house her collections of traditional Japanese art. Pei, who is of Chinese origin, agreed to the project, the only condition being that she should extend the scope of her collections to take in a more international range of art. Consequently, this extremely rich and devout patron commissioned a dealer specializing in antiquities, Noriyoshi Horiuchi, to prospect other fields. Which he did for the next seven years. All the art objects purchased were to support the congregation's ideal of beauty and peace. It was Horiuchi who decided the theme of the new acquisitions. These were to cover everything from Greek to Chinese antiquities, and would be unified by the theme of the Silk Road. "I chose this sector because it is safe," explains Horiuchi. "Unlike impressionist painting, for example, it is not overpriced. Who can guarantee that the impressionists will remain at the top of the price league?"

And so, starting in 1991, the dealer began looking for outstanding objects. His method for insuring that the best pieces came his way in spite of his being an unknown on the market was simple: He paid above the going rate. "It's no secret. If you want the best pieces, you have to pay the best prices." Stories and rumors soon started going round about the museum and its dealer. There was talk of a monthly acquisitions budget of $20 million. And, naturally, professionals besieged Noriyoshi Horiuchi with offers.

In London, Horiuchi bought all the Chinese bronzes inlaid with gold and silver put up for sale by the dealer Eskenazi in 1991. In 1994, in New York, he made a clean sweep of the Chinese jades exhibited by Lally. But the high point of his campaign was reached in London

on July 6, 1994, when Miho's emissary secretly bought a three-thousand-year-old Assyrian low relief at Christie's for nearly $12 million. At the time, it set a new world record for an antiquity. That same year, he snapped up a Chinese Han Dynasty bronze horse in Taiwan for a reported $3.5 million. Less is known about the price he paid for the outstanding Roman mosaic from Pompeii he found in a European collection. The dealer simply stated that, "It was less expensive than a work by Monet, and yet it is unique, whereas Monet painted a large number of canvases."

Today, Hiroki Koyama's collection boasts some thousand pieces, and its international selection is considered world-class. It seems logical to agree with the Franco-English dealer in Asian art, Christian Deydier, that the process of constituting it must have had a powerful impact on the market: "Prices for antiquities rose because Mr. Horiuchi was thought to have an unlimited budget." There was something almost miraculous about the transformation of the heiress's whim into a world-class museum. Since creating this institution, Hiroko Koyama has found a new cause and begun investing in organic agriculture—the museum restaurant features food that matches her vision of the world. But one of the leading players has dropped out of the art market.

Of course, other museums have played a key role in establishing or inflating market prices by virtue of their acquisitions policies. One obvious example is the Getty Museum in Los Angeles. In a world of superlatives, this institution claims to be "the richest museum in the world." Since 1982, the Getty Trust has certainly had an extraordinary amount of money at its disposal. Its assets were evaluated at $2.4 billion in 1984, and this sum has been managed with undoubted discernment in order to promote the "dissemination of artistic knowledge," as specified by the generous donor John Paul Getty. For many people, the Getty is the source of the masterpiece complex that is rampant in today's art market. Its symptom is a need to have the finest, rarest pieces with the most impeccable provenance. That said, the Getty has not participated in the recent hike in prices.

Although it continues to run the race, having bought a Titian in 2003 in a private deal said to cost $54 million and a Rubens sketch for $11 million in 2006 (sold just several months earlier at the Drouot auction house for €280,000, or approximately $328,000), it is no longer way out in front of the price stakes.

In the United States more generally, the close connections between powerful collectors (who are also major contributors to museums), museum trustees, and the museums themselves—which are still held to be the guarantors of "truth in art" and have the colossal influence to match—is beginning to look increasingly problematic. Private interests, financial stakes, and professional ambitions all have a major impact on the career of artists and on the prices of artworks.

Museums have a prescriptive power and also a preserving one, even if deaccessioning parts of a collection is sometimes authorized in the United States. Museums play such a key role in the fickle world of contemporary art that getting into an institutional collection results in better treatment in other situations. Take Dana Schutz: Born in 1976, she had not yet graduated from Columbia University when, if her resume is to be believed, she was offered a show at the Zach Feuer Gallery in New York. Meanwhile, the young artist, whose figurative paintings are stylistically located halfway between comic books and expressionism (shrewdly described by an American critic as "James Ensor on vacation in Tahiti with Gauguin"), acquired greater visibility. She showed at the Venice Biennale in 2003, entered the Saatchi Gallery stable in London in 2004, had works acquired by MoMA in New York and the Deste Foundation in Athens (an offshoot of the collection of Dakis Joannou, Greece's most important collector of contemporary art), and was included in the 2007 Guggenheim show hosted by a local museum in Shanghai, with the appealing title of Art in America: 300 Years of Innovations. All this institutional buzz obviously influenced demand for her output. Only seven canvases by Schutz have come up for auction. The highest price, paid in May 2007, was $288,000 for a painting done in 2002. Her dealer will obviously sell more recent work for more modest prices, starting at

€35,000 (around $50,000). The desire to own a fashionable work, to possess an institutionally recognized artist, or simply to make a profit by putting it back up for auction means that Zach Feuer has a long list of people waiting to buy a Schutz. Feuer, however, offers to shorten the waiting time if the buyer agrees to acquire two works, taking one home but donating the other to a museum—that's how you try to make sure an artist will go down in history. But there's no sure path to lasting fame: museums are full of forgotten talents who are stacked in back of storerooms.

New people knocking at the door

In June 2007, Franco-American broker Philippe Ségalot commented, "The current problem with the art market is that the situation is constantly shifting. After hedge-fund managers, we have the arrival of players with colossal budgets from countries that had never been in the market before." Thus in November 2006, the art world's eyes turned to New York where one of Warhol's most famous canvases was up for sale: a portrait of Mao from 1972. It was bought by a buyer previously unknown in the West, whose resolve and deep pockets got the better of the most determined European and American bidders. Joseph Lau, the Hong Kong millionaire in question, ultimately paid $17.3 million for the Warhol, establishing a new record for the pope of pop art. Lau must have been proud of his new acquisition, since he made no secret of his identity.

Also worth mentioning are new Russian buyers who are pushing up the prices of international contemporary art, but it is the Arab world that may well produce the next giant upheaval in the international art market in the near future. Indeed, the most spectacular announcement of this brand-new century came from the United Arab Emirates in January 2007. The reigning sheikh of Abu Dhabi, Khalifa bin Zayed al-Nahyan, announced that he was building a cultural center unlike anything ever seen on the ten-square-mile Saadiyat Island, some five hundred yards off the coast of his capital

city. The center is the brainchild of Tom Krens, head of the Guggenheim Foundation, and will include five museums of international scope designed by five famous architects. In addition, a biennial event will be organized to enliven the site. This new cultural megalopolis will be located in a previously underequipped part of the world. The approximate budget is $27 billion. The operation should begin opening its doors in 2012, and will include an Abu Dhabi Louvre, the Emirate authorities having paid a billion dollars for expertise from the Louvre staff along with loans from the museum and the right to use the "Louvre" label. At the time of this writing, no figure has surfaced concerning the Abu Dhabi Guggenheim, but it will be the largest Guggenheim ever built, covering some three hundred thousand square feet in a building designed by Frank Gehry. If this pharaonic project comes to fruition, it will certainly create upheavals on the art market, for at least two museum collections have to be assembled: the universal, historical one of the Louvre and the modern and contemporary one of the Guggenheim.

In the long term, the basic unit of measure used in this part of the world is one billion dollars; in the short term, it's a question of $40 million per year for the Louvre and $60 million per year for the Guggenheim—not including some outstanding works that might be acquired as part of the collection. In a matter of months, the effect had already kicked in. Heavyweight players in New York were contacted about putting collections together. The spirit of regional rivalry was also triggered: Qatar apparently now wants to endow itself with a museum of contemporary art. Elsewhere, rumors of the purchase of a group of a hundred Warhol paintings owned by dealer Jose Mugrabi (based in Paris and New York), for the alleged sum of $610 million, were circulating in the art world— the buyer is reportedly from the Emirates. Finally, a massive advertisement in international papers announced that Sheik Mohammed bin Rashid al-Maktoum, head of the government of Dubai, was putting ten billion dollars into a foundation for "the development

of education and culture." The demand for Western art can therefore only grow, and prices will be sure to follow.

That said, the constant arrival on the market of new buyers in an expansion of the public beyond "natural" lovers of contemporary art has sometimes led to a comic misunderstanding of the work. Take, for example, the American artist Richard Prince, born in 1949. He became known in the 1980s by using found images from ads and photos taken from the press. He manipulated this imagery in a spirit of magnification, reproducing it on canvas in a very large format. His most famous work, which has certainly gone down in history, shows a cowboy on horseback in the wild, imitating the classic Marlboro cigarette ads, without the logo. Philippe Davet, who runs the Marc Blondeau Gallery of contemporary art in Geneva, tells the following story. "I was at a dinner of collectors in Miami during the fair. Opposite me was an American who was talking to one of his friends. 'I own a photo by Richard Prince.' His friend said, 'I don't know that artist.' The man explained, 'He's the guy who created that Marlboro ad, you know, with the cowboy. Well, I've got a huge photo of the man on his horse.' At that point I tried to join the conversation to explain Prince's concept to my neighbor across the table. He didn't want to believe me. 'It's not worth that much if it's not the Marlboro photograph.' " With distinct irony, Davet concluded, "As far as he was concerned, I couldn't have been right anyway. I was less important than he was—I didn't own any photographs by Richard Prince."

1. Werner Muensterberger, *Collecting: An Unruly Passion* (New York: Harcourt Brace, 1995), p. 9.
2. Ibid, p. 8.

"It's not that the paintings here are expensive, it's that the money's cheap"
STEVEN O'HARA, New York art dealer

The Seller
and the price

A. CHIC COLLECTIONS

Nobody nowadays would be so ingenuous as to believe that the only thing collectors care about is the work of art and its intrinsic value. The magic of today's art market is that it offers a complete package of "dreams" along with the actual object. Buying a painting that was owned by a well-known person means, in a way, standing in their shoes, walking in their footsteps, possessing a small part of their myth. The work of art is no longer enough. The "collector label" provided by the seller serves to reassure buyers of a particular piece's value. But if you want the label you have to pay the price. Sotheby's and Christie's are masters in the art of telling stories in relation to their objects. Prices rise as a result of publicity about the identity of the owner. This is what you call the pedigree quotient.

When this reasoning is taken to extremes it leads to a pretty dismal conclusion: never mind the object, so long as we have a trace of its owner. The consumption of art leads to the disappearance of the artwork. Specialists have traced the beginnings of this phenomenon back to 1958, the year of the first high-profile sale. It was held at Sotheby's, London, and concerned the dispersion of the Goldschmidt Collection. The impressionist works brought extraordinary prices for

that time. However, no one had any inkling that this tendency would spread to other, less "glamorous" areas. For in this golden age of the trade it was still a matter of good quality paintings and provenance.

The world of public auctions today is conducive to a market in which prices are guided by the star system. In France, celebrity magazines spread the word of these honorable operations with their large-format glossy photos and short texts as eulogistic as they are insipid. And it works. A necklace of false pearls went for $211,500 simply because it once belonged to Jacqueline Kennedy Onassis, and Jackie was photographed wearing it as she kissed her young son. The son and his sister put the necklace up for sale at Sotheby's in 1996 along with 1,100 other objects, gleaning a cool $34.4 million in the process.

Yet when it comes to the promotion of a private art collection, the landmark auction was of the collection of the Americans Victor and Sally Ganz, held in November 1997. The sale of their paintings—mainly Picassos—at Christie's, brought in just over $206.5 million. This was a record figure at that time for a private collection. But the real feat here was that the heroes of the event were, as far as the public was concerned, utter nobodies—until Christie's promotion machine got to work, that is. Never before has the adage to the effect that "selling a collection effectively means selling its history" been so spectacularly borne out. The Ganzes were not members of the New York jet set. He was a discreet manufacturer of costume jewelry and not even obscenely rich. Still, it was an outstanding collection. So what would the pitch be? Christie's tactic was simple: They would focus on the history of a passion. It would be a story of a couple with relatively modest means who, by virtue of their unerring eye and radical choices, managed to put together one of the finest ensembles of twentieth-century art. Christie's chose to present the Ganzes as exemplary collectors, a lesson to all art lovers, rich or not. The history of the Ganzes, as related and abundantly illustrated in the book published for the occasion by Christie's, began in 1941 when the couple first came across a painter they had

never heard of before: Picasso. They spent $7,000 to acquire what would be the star lot of 1997, *Le Rêve* (*The Dream*), a canvas dated 1932. In this period the master painter made many passionate portraits of his then-mistress, Marie-Thérèse Walter, and considered one of the finest is the work in question. Its estimated value at Christie's was $30 million; the hammer fell at $48.4 million. (*Le Rêve*, as mentioned earlier [see page 20] was the recipient of Steve Wynn's recent elbow mishap.) The work and its pedigree has not been forgotten. In 2006 its purchase was negotiable for $135 million. According to Christie's calculations, between 1941 and 1990 the 58 lots of the Ganz Collection cost their owners $2.5 million to assemble. In 1997 they were sold for $206.5 million. It was one of the century's most spectacular investments.

During the 2006 and 2007 sales, this appropriation of the seller's eye by the buyer and the identification of the buyer with the seller—the person who had spotted the work at a time when it was not yet prized—was more in vogue than ever. This is because the new art consumers are rich, yes, but often inexperienced. The result: $72.8 million for Rothko/Rockefeller and $10 million for Peter Doig/Saatchi.

In the first case, on May 15, 2007, the American auction house Sotheby's put a 1950 Mark Rothko painting on the auction block. Composed of bands of color—yellow, white, pink, and lavender—it was owned by the legendary 91-year-old collector David Rockefeller, a powerful trustee of MoMA in New York. He had bought the work, his first abstract painting acquisition, in 1960 on the advice of the head curator at MoMA. The painting had never been on the art market, and in May 2007 was estimated at $40 million. When David Rockefeller first bought the Rothko in 1960, for less than $100,000,[1] he was a vice president of Chase Bank. In April 2005, in support of the MoMA's new projects, he pledged $100 million to the institution, the largest cash gift the museum has ever received. In addition, throughout his long career as a trustee, he had given the museum an avalanche of paintings by Cézanne,

Gauguin, Matisse, and Picasso. John Elderfield, MoMA's chief curator of painting and sculpture, told *The New York Times* that David Rockefeller had called him before putting the painting up for sale at Sotheby's: "He asked me if this was something we had to have." Mr. Elderfield had answered, "We don't need it. We already have five Rothkos from the 1950s."

So that night at Sotheby's, a painting—which was not even especially large for Rothko (205.8 x 141 cm)—reached a new height on the Everest of prices: $72.8 million. A few days earlier, *Art & Auction*, an American publication specializing in the art market, devoted its cover story to the operation. The elderly gentleman was posing in front of the artwork. It could even be said that the owner's identity was more important than the painting itself. The picture carried the syrupy caption "Even David Rockefeller gets in on the action with his ravishing Rothko." The word "ravishing" is an odd choice to tag on a work of Rothko's artistic scope, but the message itself is quite clear—Rockefeller is eager to join the game of making money with art. Even him.

In London, a few months earlier, Sotheby's—once again—sold a painting by Scotsman Peter Doig, an artist from Saatchi's stable. At the moment of this writing, if you type "Peter Doig" into Google, your first hit will be the site of Charles Saatchi, the famous British collector. The fourth image shown in the "Saatchi Gallery" is the very work that was sold on February 7, 2007, in London. It is *White Canoe*, a large canvas with obvious decorative possibilities, painted in 1990 by Scotsman who was 47 at the time of the sale. The sum awarded to this young artist, who was not yet an international name, was astronomic: $10 million. In comparison, in the hours just before or after, the Russian collector—who seems to have been the buyer—could have bought at auction more sure values, such as René Magritte's *Le Prêtre Marié*, a 1961 surrealist painting showing masked apples (sold for $7.9 million) or Andy Warhol's 1974 glamorous portrait of Brigitte Bardot (sold for $8.1 million)—made before she turned her charms to animal rights.

According to Esperanza Sobrino, a director of the prestigious Acquavella Gallery in New York, "Peter Doig is a great young artist, with much potential, but the price attained was crazy. It went so high simply because three bidders with major money were in competition for the same painting. Such market excesses often are caused by purely personal reasons." According to her, the market is too arbitrary. The Saatchi "label" sells. Three months later Sotheby's sold another Peter Doig painting in the same vein: *The Architect's Home in the Ravine* (1990), a reference to Le Corbusier's house. It went for a less spectacular but still colossal $3.6 million.

B. ON THE PLANET OF DECORATIVE ARTS

Furniture auctions also use the "collector label" to drive prices. Maurice Rheims, who died in 2003, was a great Parisian auctioneer in the days when the French capital was the center of the world art market. He dated the boom in decorative arts prices to 1955. This member of the French Academy offered this rare eyewitness account of what he called "contemporary speculation on works of art," describing the beginnings of the cult of personality that grew up around collectors. Also noteworthy is the way in which the desire for reassurance can already be seen pushing buyers to copy other people's taste. "It must have started on the afternoon of June 14. On that day, at the Galerie Charpentier, I was going to sell off the collection of a Portuguese banker, a great lover of eighteenth-century art who had died prematurely. In the packed room there were some 'big hitters of the time,' among them the architect Jean Walter, the husband of Domenica (the widow of the dealer Paul Guillaume), the Greek Nimikos, the shipowner, Niarchos (who had yet to make a name for himself), the American Rockefeller, and a few people from Milan. The furniture on offer, which was remarkable both for the nobility of its forms and for its lavishness, reflected the sure taste of their former owner. Very soon—from the second lot, in fact—it became clear that the standard market rates were going to be overturned, so

unlimited were the resources of the main buyers. From the mouths of the antiquarians who usually dominated such events, no further bids were heard. These Parisian dealers, who offered prices in their shops that were considered extremely expensive, realized that, making light of benchmarks and mercuriales [market listings], Niarchos had no qualms about paying out over three million old francs [$393,000] for a lady's desk stamped Dautriche from the Louis XV period, a piece that the day before you could have found at half that price in the trade. And so, the constant rises began as soon as they were back in their shops. Prices now would never stop swelling, inflating." This phenomenon has since accelerated, driven by the Sotheby's and Christie's war machines. It has also become more nuanced.

Today, major collectors of decorative arts no longer turn to eighteenth-century France, as they did just five years ago. While film director Sofia Coppola chose Marie-Antoinette as an icon, and the New York-based German contemporary artist Rudolf Stingel reuses typical Louis XVI motifs in his monochrome paintings, the bell is tolling for both King Louis styles. "The eighteenth now attracts collectors with a true taste for it and is much less a matter of fashion," comments antiques dealer Didier Aaron. Eighteenth-century furniture, with its marquetry, gilding, tiny ornamental flourishes, and refined aesthetic rules, no longer corresponds to today's decorative codes.

The end of the gilded period came with the closing of Maurice Segoura's Paris gallery, located on Place François-1er, which was the reference for "high style" antiques. All of the gallery's collections were put on the auction block at Christie's New York in October 2006. There were 219 lots. It was not the most favorable climate for eighteenth-century pieces, and there were few items still on the market. The lovers of the genre nervously awaited the results.

The stakes were high in New York on October 19. Some hundred people filled the hall and another twenty bidders were holding on the phone lines. The first lot would sell for more than ten times its

estimation. And the others followed suit. The evening turned into a final salute to the great antiques expert, bringing in $18 million for an estimate of less than half that. The renowned seller's name, especially vaunted in the catalog, was the key to this success. Note that Segoura's client list was a weighty one, from the Getty Trust to Bernard Arnault, from Giovanni Agnelli to the American financier Henry Kravis. The catalog read like a homage with eulogistic texts signed by clients such as Lily Safra, widow of the banker Edmond Safra; the Belgian businessman Albert Frère; and Daniel Alcouffe, former curator of the Louvre's decorative arts department. One of Segoura's close friends, Hubert de Givenchy declared, "Maurice Segoura loves great music." For the initiated that sentence meant exceptional furniture created for kings and aristocracy.

Estimated at $7 million in total, the lots that went up for sale in October 2006 did not truly reflect Segoura's taste. They included some exceptional lots, but it's obvious that Maurice Segoura did not need help from Christie's to sell the most prestigious of his objects. In general, the Christie's experts were very cautious in their estimations. For example, a Louis XVI commode with mahogany veneer, for which Segoura had paid €170,000 at auction in 2004, was put up for auction in New York with a €120,000 estimate. Underestimating was a lure to draw potential buyers, since all of the items had still been on the market just a few months earlier. In addition, all lots estimated under $30,000 were offered without a reserve price. This was necessary so that the buyers—attracted by the low starting prices—would be interested in the surfeit of pieces thrown on the market in one blow, with an overabundance of clocks and small "writing tables." The selling strategy was a proven one. Christie's had employed the same method in May of the same year and had successfully sold the "relics" from Partridge, who had been the eighteenth-century specialist in London for several decades. Ninety-one percent of the lots had found buyers, bringing in $14.9 million for an estimate of $11 million. Christie's had become the de facto specialist in selling off antique dealers' collections.

Other auction houses had claimed success as well. In 2004, the *Who's Who* columns of the art world announced the news of a sale at Sotheby's of the furniture from the apartment of Giovanni Agnelli's widow, Marella. In 2005, the firm once again made art headlines with the auction of decorative items once beloning to the widow of banker Edmond Safra. Both sales used the same fruitful recipe: Mix a taste for the theatrical with a story, and add a wide-ranging collection of objects.

Today, the popularity of eighteenth-century French decorative objects and furniture is on the wane—excepting a few outstanding pieces. It has been replaced, in terms of demand, by other French productions: 1930s art deco and rare 1950s items by Jean Prouvé and Charlotte Perriand, for example. Jean-Marcel Camard, who heads the auction house of the same name and specializes in twentieth-century decorative arts, observes: "There is a European and American clientele in the Art Deco sector—often people from finance—that is growing and able to pay very high prices, which [are] now going beyond a million euros."

The proof is on record. On June 1, 2005, a lacquered 1920s armchair by Eileen Gray, one of art deco's grand priestesses, was sold in Paris by Camard & Associés for €1.7 million. Never had such a sum been spent on an armchair from any era. This was €500,000 more than the €1.3 million spent a few months earlier at Sotheby's in Paris for a Louis XV chair stamped Heurtaut—already a record. The next episode of the Art Deco saga took place on June 8, 2006, at Christie's in Paris when a pair of 1920s jardinières by Armand-Albert Rateau went to a French antique dealer for $5.3 million. They had belonged to a couple in Neuilly-sur-Seine who had collected furnishings and decorative art by well-known 1920s and 1930s designers. The couple were not myth-making connoisseurs. Their sale simply happened in an especially favorable climate. Never in the history of auctions had the sale of decorative art reaped so much: €59.7 million. Thirteen of the pieces fetched more than one million euros each. That the sale was held in Paris—art

Deco's creative cradle—added a certain charm for buyers who made purchases that day, 40 percent of whom were American. It was another return to the roots of a style via the auction house.

C. THE FRENCH SITUATION

The most notable sale in France in the past fifteen years was the dispersal of the contents of André Breton's studio by the small auction house Calmels-Cohen in 2003. No big promotional money, but golden material with which to work. For nearly 40 years, the founder of surrealism had stayed in the same smallish apartment stuffed with souvenirs, artworks, documents, and relics of every sort. He lived in Paris at number 42 rue Fontaine, in the Pigalle neighborhood, where in 80 square meters he created his own amazing world. The seemingly heteroclite collection was a mental construction equal to the poet's mind: documents, religious paraphernalia, paintings by famous artists and by those likely diagnosed insane, Oceanic art, photo souvenirs, manuscripts, and everyday objects picked up in the street. Back when visitors crowded into his studio, Breton wrote that he "always felt the urge to take the first broom found in the kitchen and throw [the visitors] all out." André Breton died at the age of 70 in 1966. His atelier, temple of the twentieth-century avant-garde, was kept untouched by his last wife Elisa until 2002, then by his daughter Aube. Then, in 2003, Aube decided to sell.

After 21 auction sessions, three thousand catalogs, weighing eight kilos (about 17 and a half pounds) each had been sold. The 4,100 lots had been dispersed in 52 hours for €46 million—50 percent more than the original estimate. Would Breton have been pleased? When in 1919 the poet, along with Aragon and Soupalt, published the first issue of the revue *Littérature*, they were disappointed by the intelligentsia's positive response to their work. "Success, phooey!" they declared, "What matters is to be undesirable." But as time went on Breton was quite capable of playing with the market's ups and downs.

Truly, the trick of supplying a convincing history, combined with expertise and efficient public relations, was pushed to the limit in 2006. French experts on primitive art Alain de Montbrison and Pierre Amrouche organized the sale of Pierre and Claude Vérité's African art collection under the aegis of Enchères Rive Gauche, an unknown firm, which seems to have been created for the occasion. There was none of Christie's or Sotheby's heavy artillery, but the customers showed up. It was the best of timing since it coincided with the opening of Quai Branly—the French museum of "Arts Premiers," designed by the architect Jean Nouvel. It must be admitted that the Vérité sale was a truly historic event, objects collected in such great number and over such a long period of time, could no longer be found on the market. The pedigree was a supreme guarantee for amateurs in a sector crawling with fake artworks. Collectors were given the certitude that the expert eye of a well-informed person—the famous collector—had studied the item and chosen it before them. It also insured the potential buyers that the object was not recent. The Vérité sale could be summed up as 514 lots, a 600-page catalog sold for €100, four sales rooms at Drouot reserved for the event, and an overall estimation of €10 to 15 million.

The father, Pierre Vérité, a disillusioned artist, sold primitive art in the Montparnasse area, starting in the early 1930s. His son Claude worked alongside him and took over the business in 1965. He was 77 at the time of the auction sale. It should be noted, however, that as of the 1970s their gallery, the Carrefour, was somewhat criticized by professionals. "As of 1965 the arrival of objects dried up. Substitute pieces of lesser quality, which were little used in rituals and not very old, were sold," admitted Pierre Amrouche. In addition the Vérités were always a bit secretive. When they loaned pieces to exhibitions that would become milestones of knowledge about African art, the Vérités always requested that their catalog credit read "private collection."

It's thus clear that the name Vérité was not synonymous with a celebrated African art collection, as was the case of Helena

Rubenstein, whose collection was sold in 1966. Nor were the Vérités known for a selective eye as dealers, in the manner of Charles Ratton, for example. As a professional, who prefers to remain anonymous, explained: "The Vérités were accumulators. And if you've been accumulating since the 1930s, there are always good items, even if certain major pieces were recently sold to foreign institutions."

The results went beyond all expectations. A sleek Fang mask skyrocketed to €5.9 million—a worldwide record for a piece of African art sold at auction. It was bought by a mysterious French collector, a woman. In all, the auction brought in €44 million—four times more than the official estimate.

1. *White Center (Yellow, Pink and Lavender on Rose)*.
2. "Histoire des mœurs," edited by Jean Poirier, "Encyclopédie de la Pléiade" (Paris: Gallimard, 1990).

"The best art is the most expensive, because the market is so smart."

Tobias Meyer,
Sotheby's worldwide head of contemporary art

The Intermediary
and the price

In an ideal world, where the art market is a simple place, there are two distinct categories of intermediary between sellers and buyers:

—The auction houses, which are there to apply the law of supply and demand by selling artworks at auction as openly and transparently as possible

—The dealers and gallerists, whose sales are more discreet

In the real world, though, things are much less cut-and-dried. The colossal sums of money at stake have transformed these middlemen into purveyors of a variety of services. These new Shivas of the art market—both creators and destroyers, capable of sweeping up the little world of art in their cosmic dance—will, in turn, sell, buy publicly or secretly, finance, advise, dissuade and promote but also guarantee, acting like art critics and even art historians. They take on these, often incompatible, roles without any qualms, for the sole purpose of pushing prices higher and higher.

A. AUCTION HOUSES: THE SHIVAS OF THE ART MARKET

The Impact of Auctions

"What makes for a successful sale? Apart from the quality of the works involved, the policy regarding estimates, the work of appraising, promoting, and also, preselling the objects are all necessary for a good result. The finishing touch is added on the evening of the auction itself, when the auctioneer holds the hammer. If you had the same lot sold four times over by four different auctioneers, you would be sure to get four different prices," said Simon de Pury, formerly director of Sotheby's Europe and then high-flying broker, who has been conducting auctions since 1976. Today, he is at the head of the world's third-leading auction house, Phillips, which specializes in contemporary art, design, and jewelry.

De Pury is well aware that it is the auctioneer who orchestrates suspense during the sale. His looks, the rhythm with which lots are put up for sale, along with his psychological appreciation of potential clients' attitudes, are of considerable importance to the success of the operation.

An auction is like a game of roulette at the casino. It makes the heart flutter, gets the adrenaline flowing, and overcomes reason. To have or have not? For a few moments, the competing bidders in the room or over the phone[1]—or perhaps nowhere at all —are mortal enemies. There is fear of stopping too soon, anxiety at the thought of going beyond "the reasonable limit," of yielding to the friendly temptations proffered by the auctioneer, or of becoming a person with no material limits before the gaze of the excited public, as in Dostoevsky's *The Gambler:* "I remember clearly that I was suddenly, and without any incitement from *amour propre,* overtaken by the thirst for risk. Perhaps after going through so many sensations, the soul cannot be satisfied but only irritated and demands new, ever more violent sensations, to the point of total exhaustion. And really, I am not lying, if the rules had allowed me to bet fifty thousand florins in one go, I would have risked them ...Around me people were crying that it was insane."

Everything is decided in a matter of seconds, and the fate of the potential buyer is not known until the last moment. The history of the art market is full of these mad battles between two enthusiasts who end up paying astronomical sums for a lot that really wasn't worth it. The role of the auction house is to push this principle to the limit. "That is the magic of auctions," blasé initiates often comment. Consequently, there is usually a rift between the prices set by the hammers of the auctioneers and those charged by the galleries.

Auction houses: driving the market to the limit

It should be said that due to their catalogs and various promotional activities, the auction houses are particularly well placed to stimulate this appetite for fashionable types of objects. In order to achieve this, they use a variety of strategies that take them a long way from their original role as intermediary. In addition, the firms now use powerful marketing devices whose effect is, obviously, felt in the form of higher hammer prices.

According to Marc Blondeau, former director of Sotheby's France and a broker based in Geneva, auction houses are now in the hands of businessmen and managed like any other business. "At Sotheby's or Christie's, the idea of artistic expertise is losing ground to the power of an administration driven by accountants and business development plans. And so the market is being dragged towards financial speculation. The aim is to push prices higher and higher, irrespective of the intrinsic value of the work...What is sold is the 'image' of the work and not its real content."

It's not just a matter of chance that in many transactions—made both at auction houses and by dealers—the buyer has seen only a reproduction of the painting, sculpture, or photograph. The question here is not whether it's a good or bad reproduction. It even less concerns the artistic qualities—thickness of the paint, brightness of the colors, strength of the composition, etc. Instead, it's a question of social vanity and speculation.

Florence de Botton, head of contemporary art at Christie's France, denies that speculation is common practice: "Of course, there is speculation in certain areas, such as contemporary Chinese art. Some people go specifically to Beijing galleries to make purchases that they hope will quickly resell in the West. But overall, the current rise in the art market has more to do with the fact that there is a lot of available money and that more and more people are buying. With the growing number of art fairs, the field has become very accessible—and very desirable. In some ways it has become mixed up with the world of luxury items."

Diego Cortez, a former artist and now an art consultant based in the United States, was interviewed for the small catalog of the exhibition, The Price of Everything, which ran until June 24, 2007, at the Whitney Museum of American Art, in New York. In his opinion, "The speculation game has grown enormously. It's fueled by the auction houses, by galleries, and even by artists—they're all happy to take the money, but many will not admit it. They complain that speculation is suffocating the artwork, which is true. But many collectors are obviously speculating—that's the reason prices have risen so enormously. It doesn't mean that everything is for sale, just that certain holdings are more valuable."

That's the catch: not everything is for sale. With so much demand and cash flooding the market, the only way to tease exceptional artwork out of collections is for brokers to guarantee astronomical sums to sellers for their goods.

This new tendency reached its pitch during the New York modern and contemporary art sales in May 2007. The season's most striking feature was the height of the estimations. Every star work was tagged with a value above the record price brought by the artist's other works. The auction houses, perhaps in spite of themselves, fuelled the fire when it came to estimates. For example, on May 8, 2007, Sotheby's sold an especially accomplished Cézanne watercolor, *Nature morte au melon vert*. It belonged to Giuseppe Eskenazi, a Chinese art dealer based in London, who for his private

collection had once wanted to try a different domain than his specialty. He made the right move. Eskenazi bought the Cézanne in 1989 at Sotheby's for a record price of $4.3 million. In 2007, it was put up for auction with an estimated worth more than $10 million, and the hammer price was $25.5 million—setting a new record for a Cézanne watercolor. One week later, Sotheby's put a 1950 Mark Rothko, belonging to David Rockefeller on the block (discussed earlier, see page 71). The work had never been on the market and was estimated at $40 million.

What was the record price paid for a painting by Rothko until that time? In 2005 at Christie's, *Homage to Matisse*, a painting from 1953–1954, was sold for $22.4 million. Due to the provenance of the Rockefeller/Rothko and its decorative value—the colors are attractive—and in spite of its modest format (205.8 x 141 cm), Sotheby's decided to raise the bar on record price. They estimated the painting at $17.6 million more than the Rothko that sold at Christie's just a year and a half earlier. It seems that David Rockefeller had been promised a guarantee[2] of $46 million by Sotheby's. The hammer price: $72.8 million.

On May 16, 2007, Sotheby's competing auction house, Christie's, put forward Andy Warhol's 1963 *Green Car Crash*, from the heart of his pop period. Not a glamorous Warhol, it was inspired by a newspaper clipping of an auto accident. The painting, however, is part of the artist's famous obsessive series "Death and Disaster." It was estimated at $25 million. Once again, the previous record price for a Warhol was slightly less. It had been set in November 2006, when a large Mao portrait was bought by a Hong Kong resident for $17.3 million. Before even hearing the hammer go down, a Christie's press release announced that, "This sale is bound to set a new price structure for the artist." And they were right. *Green Car Crash* brought in $71.7 million.

Even before the auction, Tobias Meyer, Sotheby's worldwide head of contemporary art, noted, "We're used to saying that the art market is a cyclical market, but that given has become obsolete. In

the past, the art market only concerned the United States and Europe. Today, the demand is just as much fed by India, Russia, and China. And this is only a beginning. These new buyers are interested in Warhol, Rothko, de Kooning, and Richter. They are excellently advised and are looking for absolutely exceptional pieces. They appreciate the auction houses because they guarantee a certain transparency, and they know that as buyers they will pay 10 percent of expenses and nothing else. They are guided by desire and not by previously acquired pieces. They could be compared to an earlier generation of people who acquired extraordinary amounts of money and built extraordinary collections, such as the Mellons or the Vanderbilts in their time."

Tobias Meyer refers to the twentieth-century art market niche coveted by the richest of the rich as "the trophy market." It kicks in when a work approaches or goes beyond the $10 million mark, and it concerns some hundred people worldwide. Under that threshold, according to Meyer, works are aimed at a group of specialized buyers, looking for particular pieces. For this Sotheby's specialist, however, the art market is not mad: "Compare it to the housing market. The top prices are less extreme. It's only beginning. You will see..." And after the auction, like Christopher Columbus discovering America, he declared to the press, "It's a new world."

The French-born, New York art broker Franck Giraud is more circumspect about the price madness. In June 2007, he confided: "People have confidence in today's market. By pushing estimations to such limits, we risk destabilizing values and the diagnosis of professionals on this subject. Auction houses are in the process of imagining—and not anticipating—prices that could exist tomorrow. In addition, they're giving guarantees, a practice that is upsetting the usual play of offer and demand. The price actually paid is not always the hammer price. Still, I have to admit that we're not yet seeing any signs of a crisis."

The crisis—an ominous question. It's sitting in the back of the mind of each and every player in the art market as they continue to

feed a feverish system, hoping that the apogee of prices will be eternal. It's like the joke about the man falling from a skyscraper: "Up until now, everything is fine, until now everything is fine, until now…" The crisis should arrive when economic, political, and geopolitical events come together and have an effect on the market. In the meantime, the machine that produces art market values will continue to run at full speed. At the end of June 2007, the beginning of a crisis could be seen in the area of American hedge funds and the poor sales of several Warhols at London auctions. This was a good illustration of the adage that was on the lips of the more sensible art dealers, "Trees don't grow to the sky." In the early twentieth-century, the renowned dealer Ambroise Vollard wrote the end of the tale: "In spite of everything, everyone forced themselves to believe that there was just a bad stretch to get through and that sooner or later the money would again start to roll. They stood their ground and waited for the customer. The entry bell chimed…The door opened. It was 'him'! It was, in fact, an art lover, but he had come to sell."[3]

The keys to credibility for auction sales

As art collecting has become a significant social phenomenon, auction houses have turned into highly skilled event organizers. Whether hip or festive, chic or retro, scholarly or dogmatic, these bashes all serve to gild the image of the work being put up for sale. And the customer will pick up the tab for this additional glitz. In other words, the record-breaking houses of Christie's and Sotheby's have become "brands of paintings," with an image—depending on the field—for scholarliness (talks), fashion (parties), or luxury (glittering dinners).

Extraordinary as this might seem, it is now openly admitted by a number of curators that auction houses can be a perfectly respectable source of historical art references. They have indeed come so far along this road that these purely for-profit outfits are manifestly considered as theoreticians of art. Which, of course, is all to the good when it comes to talking up the product's value.

For example, in the catalog of the very high-profile exhibition Picasso Érotique, held in Paris from February to May 2001, Robert Rosenblum, a respected curator and professor of art history at the University of New York (who has since passed away), readily cited a Sotheby's sale catalog from May 5, 1999, in his essay on the *Demoiselles d'Avignon*.[4] "My information on this painting [the fact that it caused a scandal in Barcelona before being exhibited in Paris] comes from an auction catalog."

In the same spirit, at the end of 2000, the Zurich Kunsthaus presented Hypermental, a major exhibition about the "crazy reality" depicted by contemporary artists. A film was shown in the middle of the exhibition featuring Jeff Koons speaking to an interviewer about his work and aims, and the fact that he didn't think of his art as kitsch. Nothing strange about that. But then, suddenly, the words *the sale* flashed on screen. What did this mean? What was the Kunsthaus selling? Nothing. It had simply borrowed the cassette of the interview from Christie's, who used it to promote that year's May sales of contemporary art in New York.

It must be said that when so much money is at stake, the means employed to boost the credibility of a work are colossal. For example, in May 2007, when Christie's sold Warhol's *Green Car Crash* for $71.7 million, they had eagerly produced a 110-page glossy catalog, devoted solely to that work. They also showed a film, via Internet, of an interview with Gerard Malanga, a poet who had worked with Warhol at the Factory. Hooking buyers with references has become an auction house's job.

For impressionist and modern works, another technique is used. Here, there's no question of comparing one reference to another older one, one simply shows that past work was held in good hands. The height of this practice was reached, though not intentionally, in November 2005. That season's catalogs looked like family photo albums, filled with snapshots of the American aristocracy as one might imagine them in the 1960s—gathered around a fire not far from a Picasso or a Pissarro. The Schambergs of Chicago, for example, are

pictured facing a Juan Gris estimated at $2.2 million and given a page-long biography. We learn that Madame Katherine, known as Kay, "sadly died at the age of 102" and that "she attended meetings of Chicago's Contemporary Art Museum until she was 90 years old." Further on, we meet Selma and Israel Rosen from Baltimore. A black-and-white photo shows the loving couple in their living room—she's seated at his feet. They too have the right to a full-page biography, and four works from their collections are offered for sale. The copywriter's enthusiasm is boundless: "It is with great pride and great excitement that Christie's offers the Rosen collection for sale in this month of November." The works on auction were estimated at $2.5 million. The catalogs are much more than art reproductions, but represent the phenomenon of the "celebrity" slipping into auction sales.

Certainly, Phillips is the auction house with the most glamorous mode of attracting buyers. The firm, installed in New York, London, Zurich, and Paris, now organizes "Saturday@Phillips" sales, held on Saturday mornings every other month. Each sale has an individual oversize catalog. The director, Simon de Pury, first came up with the idea in New York. The target: future buyers, between twenty and thirty years old. The means: a catalog that looks like a trendy magazine, featuring interviews conducted by what Phillips calls taste makers. These taste makers reveal what they think is good and not so good in the collection on sale that day, as well as their personal feelings about the art and their moods. In the Saturday@Phillips sale of March 10, 2007, the lot estimates—for design, photos, art, and jewelry—were not especially high. An edition of *Puppy*, a porcelain dog created by Jeff Koons, was estimated at $2,000 and a George Nelson table at $1,000.

Browsing the catalog from the sale, you can contemplate portraits of Malcolm McLaren—the former manager of the Sex Pistols—who talks about his empty apartment in Paris and dog droppings on the city streets. And you can read Alasdhair Willis—head of a new design firm in London—lauding the importance of Dutch designers...that he doesn't sell.

Finding new areas for their expertise. That is the leitmotif of today's art market players. Auction houses have high overheads, and to insure their profitability they must look further—and differently.

As a result, since 1999, Christie's and then Sotheby's have expanded directly to the core of contemporary art. While in the past they presented confirmed artists, today they flirt with new, up-and-coming talents that are already selling for big money. In a way, the houses are playing the role of curators by picking and choosing works from artists that are not yet on a solid career path, with a strong customer network. The principle is simple. The auction house selects a stable of artists from among the hottest and youngest talents for its catalog. Each piece that is put up for sale is chosen from the cutting-edge category. It also comes with the label of approval from a network of leading international galleries from Berlin to Los Angeles, and a few museums along the way. Here, the underlying message to buyers is as follows: "You missed the pieces that made them famous a few years ago. This is your last chance to catch up by buying an artist who, we have every reason to believe, will go down in history." The approach has proved successful beyond the auction houses' wildest dreams. In New York in May 1999—only the second time this new style of sale was employed—it notched up no less than twelve record prices.

Looking again at the results of May 2007, which was a key turning point in the new art business, there were forty-one price records broken at auction between Christie's and Sotheby's. Some of these were recent works or pieces done by very young artists: $824,000 for a 2002 painting done by the German Daniel Richter (born in 1962), $396,000 for *Airplanes*, by Wilhelm Sasnal—a Polish painter, born in 1972, that Christie's vaunted as "the rising star of former communist Europe," and $480,000 for the 2004 *Familie O-Mittag*, by Matthias Weischer (born in 1973), which was discussed earlier.

This taste for youth and fresh paint follows a trend already set by galleries that consists of searching for and uncovering tomorrow's Warhol or Picasso. That phenomenon will be discussed further on in the chapter dealing with gallery activities. Yet, the auction houses, with

their official prices, printed and distributed worldwide via their catalogs, often play the role of spokesperson for galleries. The auction houses' frenzied quest for respectability, which often seems to follow the precept, "In order to gloss over the fact that we sell, let's stress the fact that we know and love art," sometimes brings them to pose as or see themselves as museums. This is especially the case in the area of contemporary art.

What better way to sell an artist who is appreciated by a limited group than by associating him or her with well-established artists? That's exactly what was done with Barnaby Furnas, who is typically represented by New York's Marianne Boesky Gallery. Born in Philadelphia in 1973, he now lives in New York and specializes in combat scenes. In November 2006, Sotheby's sold one scene for a record price of $520,000. *Heartbreak Ridge* had been painted only four years earlier. Five pages of the gallery's catalog were devoted to this "hot" artist. His work was placed next to one of the monuments of art history, Paolo Uccello's *The Battle of San Romano*, painted circa 1435. The parallel was daring, considering that in August 2006, the young artist himself had confessed to *Vogue*, "That was the second big battle painting I did. I was thinking about how to make a kind of blockbuster painting, one that would compete with a big movie. I'd just seen *The Matrix*."

The case of Scottish Peter Doig can also be cited. His 1993 landscape painting was compared to one by Pieter Bruegel the Elder (born circa 1525). Other examples include the anonymous *Mary Magdalene* (circa 1615) that was matched to American Lisa Yuskavage's *True Blonde*, a portrait of a woman with a less than lovely face, and the 2001 interior by Matthias Weischer likened to Vincent Van Gogh's *La Chambre de Van Gogh à Arles* (1888). That is the way buyers are hooked time after time, from one catalog to the next. It only takes ideas, images, and solid documentation.

The auction house as a private dealer

Having built a reputation on the media blitz applied to their successful sales, the ever-hungry auction houses have, for some time now, been moving in the opposite direction. They readily offer private deals where the main characteristic is at their discretion. In November 1997, in the middle of the media war between the two rival giants, Sotheby's failed to find a buyer at auction for Modigliani's *Nu couché aux bras levés*. The house attempted to save face by mentioning in the post-sale press release that the prospects for selling this painting by the Paris-based Italian were still good. It was later revealed that the work was sold for $9 million.[5]

This was the first time a private deal, which is supposed to remain as such, became a weapon in the war of communications. But it was certainly not the last. In true auction house fashion, once again the method was to raise the asking price of the private transaction as high as possible. Another way to push estimations sky-high.

The game of divvying up the art market has had a lot of action in the past few years. The most noticeable split took place in 2006 and 2007. Robert Noortman, one of the leading dealers of old masters paintings worldwide, is a prime example. He had recently made several major sales, including a Rembrandt, when at Maastricht in June 2006 he announced that he had negotiated the sale of his firm to Sotheby's, to keep it functioning. The following January, he died of a heart attack. Noortman was a founder of the Maastricht Art Fair, and in March 2007, his gallery's booth was there as usual. This time, however, as sometimes happens in this Manichaean world, the booth became property of the "enemy camp," that of the auction houses. At the show, the gallery offered its standard fare: old masters and impressionists. Christie's, however, demanded equal rights from the organizers of this leading art fair, and managed to get a booth like its competitor. For the first time, they too were selling at the art fair—under the name King Street Fine Art Limited, coined especially for the occasion. Behind the booth was a firm that typically carried out private transactions for the auction house. They showed

works from various periods placed by clients in consignment, including a Louis XV commode with spectacular gilt bronze by Charles Cressent (€2.1 million) and a contemporary painting by the British artist Jenny Saville, known for her large-format works, portraying the unease of obese bodies (€1.2 million). Because of the lack of transparency behind the auction house stands, controversy buzzed during the Maastricht show.

A few days earlier, Christie's announced that it had acquired Haunch of Venison, a British gallery specialized in cutting-edge contemporary art. An outside observer might wonder why the auction-house giants were trying to take hold of a part of the market outside of their usual sphere. The answer is simple: In a market of heavy demand, the most money is in private transactions. The expenses are less for public relations, advertising, and the auction space; there's greater flexibility in the transactions; the calendar is set according to offer and demand; and there's a guaranteed confidentiality that attracts certain sellers. For Sotheby's and Christie's new partners, the advantages are just as great. The partnership gives the galleries access to the firms' enormous client lists.

In fact, the client list provides not only the name of the last buyer of a 1932 Picasso, but also the names of the five bidders who did not succeed in carrying away the prize, but who were ready to invest up to $25 million to own a painting of that style. It's also a way for the market to encourage new players to join as both buyers and sellers.

Finally, among the factors that make auction houses multifaceted actors in the market, are the paintings they already own and then put on the block during their individual auctions. The most talked-about, recent example is that of Peter Doig. According to Tobias Meyer of Sotheby's, British collector Charles Saatchi proposed the deal to the American firm in 2006. "We bought them for an elevated price," confirmed Meyer. The end of that story has already been told. The first painting was sold for $10 million, the second for $3.6 million—prices without precedent. You can guess that Sotheby's more than made back their investment and that

Charles Saatchi must have been biting his nails. You may wonder if there might be a conflict of interest when an auction house is the judge and plaintiff, the seller and intermediary. Up to what point will they show favoritism to their own property? The same question could be posed if Christie's held an auction selling the work of artists represented by the Haunch of Venison gallery.

B. THE DEALER IS A BRAND

Auction houses are not the only ones that keep pushing prices up. There is a kind of snobbery surrounding the best-known dealers that can be compared with what you find in the world of jewelry. The pleasure of buying a diamond on the Place Vendôme, in Paris, will cost you a great deal more than going to a wholesaler in Antwerp, Belgium. The same logic applies in the art world. For most art lovers, buying a painting at Krugier in Geneva, from Beyeler in Basel, or at Acquavella in New York—some of the art market's "classic labels"—brings a guarantee of artistic status. Over the last few years, dealers have been pushing prices ever upward. The development of art fairs—those supermarkets and temples of compulsive art consumption—combined with the scarcity of top-of-the-range products (if it weren't rare, of course, it wouldn't be expensive) has led these professionals down the road of excess. Today, many prominent figures simply serve as resellers of works that have already been through the auction system.

These days, when new money seems irresistibly attracted to contemporary art, the buyers all want to sign the same works by the same artists. And so the gallerists do their best to meet the demand. This phenomenon has been going on for several years. In 2000, at Art Basel, the London-based Antony d'Offay (who has since stopped his activity as an actual dealer) presented a pair of black-and-white photographs by the American artist Charles Ray. *Plank Piece* apparently shows a man uncomfortably wedged against a wall by the eponymous piece of wood. Less than one month earlier, on May 17, d'Offay bought the work from Sotheby's New York for $368,500. He was now asking in the range of

$100,000 more. For d'Offay "auction prices are fair." Really? Rafael Jablonka in Cologne sees no reason to differ with d'Offay: "Speculation? But the whole art market is speculation, and of course hammer prices influence dealer prices since professionals frequently make their acquisitions at auction."

This merry-go-round of prices is possible since certain galleries are known for their stamp and their taste. Labels pay. The best brand on the planet for contemporary art is certainly Gagosian. They own three galleries in New York, one in Beverly Hills, and two in London, with offices in Paris and Rome. Their stable includes artists as sought-after as the Japanese Takashi Murakami, pop artist Ed Ruscha, ex-young British artist Damien Hirst, American Jeff Koons, and Marc Newson, the young designer of the moment, who fetches record prices at auction. Gagosian has also taken over the estate of the recently deceased artist, American Steven Parrino. Much admired by the young generation of painters, Parrino died in a motorcycle accident in 2005, at the age of 47. A biker, rocker, and painter with conceptual leanings, according to broker Philippe Ségalot, prices for his work could easily be multiplied by five when stamped with the Gagosian label.

Each city has it leading labels: Hauser & Wirth, with spectacular premises and a radical selection, in London; Emmanuel Perrotin, with top-market international artists, in Paris. Galleries, but also brands.

Each specialty has its brand-leading gallery. Per Skarstedt, in New York, is the sure leader of the secondary market—galleries that show artists' older works, rather than their most recent productions. Why Per Skarstedt? Because very early on they represented names that have become market references, including Cindy Sherman—who stages herself in sophisticated oversize photographs—and Richard Prince, who as discussed earlier, makes paintings of images taken from the press. Per Skarstedt's most amazing feat took place at Art Basel in June 2004. Their booth presented a work by Prince, who just two years earlier was an artist interesting only to a select few. Prince had made "Spiritual America," in 1983, by re-photographing an image found in a magazine of budding star Brooke Shields, nude and made-up, getting

out of the bath. Only one print was made of the disturbing image, which would later be printed in an edition of ten. For the occasion, the dealer staged the work in a refined setting. It was sold to a European collector for a record-breaking price: one million dollars. At the time, no contemporary photograph had fetched such a sum.

Like auction houses, galleries are always on the lookout for new territory. While on the one hand, they promote fairly recent work, such as Richard Prince's 1980s production, on the other hand—in an effort to keep up with today's youth-oriented society—they seek out new talent, fresh out of art school. As Eleanor Heartney noted in *Art Press*, "In 2006, Yale University reported that half of the graduating MFA painting students were already showing at galleries." This trend is exaggerated by art market financiers who act like investors. The New York dealer Jack Tilton, who "sells" young artists, declared to *The New York Times*, "Now we take them six years earlier, like a basketball league." In 2005, he staged a show called School Days, featuring nineteen artists from major East Coast art schools. In two days, 70 percent of the works by these young unknowns were sold at prices ranging from $1,200 to $16,000.

This premium on youth can be perceived throughout the art world. Rik Reinking, a collector from Hamburg, was given a booth for free at the 2006 Cologne Art Fair, where he showed pieces from his collection. Age twenty-nine at the time, the young man turned slightly gray from all of the brouhaha surrounding him. But from the start, Rik announced that he had limited financial means: "I don't have family money. I studied art history. To make a living I do research on paintings for private collectors. Their author, their pedigree . . ." Yet he manages a six-thousand-square-foot exhibition space in the Hamburg theater district. He insists that it can be run with an extremely limited budget. And he justifies this by saying, "There's nobody to show young artists. Young artists, that's my language, that of my generation; I organize six exhibitions per year. Among other places, my collection has been shown at Leipzig and Bremen, and there are plans for other places in the rest of the world, Istanbul for

example." In November 2005, Rik Reinking, the young discoverer of young talents had already been a sensation at the Cologne Fair.

During the 2006 Paris FIAC, the Alain Gutharc gallery showed the work of Marlène Mocquet, a young woman who had graduated from art school just a few months earlier. She was noticed immediately by the gallerist, who sold twenty-five of her paintings at the Paris fair. A buzz effect had grown around her paintings, which are animated by characters that spring from splashes of color. The syndrome of searching for the new Warhol had struck again.

Finally, the latest field to be conquered by contemporary art galleries is that of design. With work by current artists becoming rare, it's tempting to attack the promising and closely related field of design, which attracts the same customers. And all the more so since the line between art and design has become so thin.

Australian Marc Newson is certainly the designer that crossed over most easily. His path had already been cleared by the auction houses. In 2000, Christie's presented *Lockheed Lounge*, a chaise longue, riveted using a technique that Newson borrowed from the fabrication of airline cabins. It was presented at a contemporary art auction and reaped $90,000. The same sort of operation was repeated in 2006. A riveted anthropomorphic commode, inspired by an André Groult art deco piece, was put on the block between works by Warhol and Basquiat, and brought a hammer price of slightly over $1 million. To spice up the story, Madonna chose a chaise from Newson's Lockheed Lounge series for a video clip. The chair and shimmying star were seen around the planet.

The Gagosian gallery held their first design show in their Chelsea, New York, space in February 2007. The designer was Marc Newson, of course, and it was a stunning success. It has been rumored that the show brought in $26 million. A marble bookshelf that stands like a vertical web, produced in a limited edition of eight, gleaned $475,000. A clean-lined nickel chair, in an edition of ten, brought $140,000. But is this art or design? In the show's catalog, the artist gives his own opinion, "If I were really forced to define my work, I would call it functional sculpture."

Since 2006, Michael Hue-Williams has been showing the work of the Campana brothers in his London gallery, Albion. The Brazilian designers will go down in history thanks to their cartoon chairs covered with piles of plush animals. "We sell a piece every two or three days," the gallerist joyfully recounts. They're worth between $10,000 and $200,000. I realized the interest of design by collecting first of all for myself. Contemporary art and design go well together in an interior. And then the distinction between art and applied arts is not pertinent." Hue-Williams is even preparing the catalogue raisonné of the São Paulo duo. Art, design…the same combat? The tendency is catching. In June 2007, Thaddaeus Ropac's Paris gallery announced that it too would be joining the game by showing designs by the Frenchwoman Matali Crasset.

The new forum that's spreading the trend: fairs devoted to the genre. Surfing on the wave of design consumed as art, they've been scheduled alongside art fairs in event calendars. For example, Design Miami takes place at the same time as Art Basel, in both Miami and in Basel. And in October 2007, during London's Frieze Art Fair, the Paris FIAC, backed by the capital's traditional influence in the field of decorative arts, presented the disciplines of art and design in the same place.

Still, it's worth stepping back to take a less heated look at the contemporary art market. Remember that, in general, all these transactions take place in an atmosphere of extreme uncertainty. Nobody knows if the choices made today by galleries, then mimicked by museums and collectors, will be confirmed by history. Rules about the importance of a creation have become arbitrary, or at least relative, since art is no longer required to be truly beautiful or to present any sort of technical virtuosity—or as Duchamp put it, be "retinal." You like it, or you don't. During a roundtable organized by the American branch of the International Association of Art Critics, Don Rubell, a contemporary art collector from Miami, analyzed his choice of young artists, "My nightmare is that we might be wasting our time looking at bad work, like in 1880s France. We're all looking in the same place, but is it any good?" And the art critic from New York's *Village Voice*,

Jerry Salz, added, "The art market is now so prevalent that to condone or condemn it would be like condoning or condemning air. To say, 'I refuse to participate in the market' is like saying, 'I refuse to breathe.' "

Making a sale for dealers and gallery owners depends on nothing more than their own conviction. They don't need to explain a work using art history or cultural details. The best art dealers today are unequalled salespeople who show unshakable confidence. A former museum curator, now a British gallery director, confirms this analysis: "When you arrive in Chelsea, if you visit the galleries, there are five hundred or more artists being shown. But to sell them, the person showing the work has to believe in it. Simply look at the Venice Biennale from fifteen years ago. How many artists have left a trace?"

Finally, isn't uncertainty one of the inherent parameters of the existence of what is called "contemporary" art? As early as the nineteenth century, Paul Durand-Ruel, art dealer of the impressionists, exclaimed about Cézanne's painting, *La Maison du Pendu*, now at the Musée d'Orsay, "Well, yes, of course, I bought a painting that is not yet accepted by everyone! But I'm covered: I have an autograph letter from Claude Monet giving me his word of honor that this painting is destined to become famous. I've kept it in a little pouch tacked behind the painting, at the disposition of any of the malicious who would like to go nit-picking on my head."[6]

C. THE FAIR, THE ART MARKET'S NEW BATTLEFIELD

The art market has metamorphosed and with it the way that art is consumed. In the past, from New York to Paris, it was the custom for collectors to make the rounds at galleries every Saturday morning— whether they were lovers of primitive, modern, or contemporary art. It gave them a chance to satisfy their curiosity, see what was new on the market and meet other art lovers. Things work differently today. The market is international and most collectors follow the events. If I like antiques, I would go to the Netherlands to Maastricht, in March. If I

like twentieth- and twenty-first-century art, it's Basel, Switzerland, in June. For up-and-coming young artists, there's Brussels in April and Turin, Italy, in November. And for fashionable art and a party atmosphere, I would fly to Miami in December. That might be a bit of a caricature, but still, art fairs have become art supermarkets. They offer lots of advantages. First of all, there is a concentrated selection up for sale. Secondly, there are a good number of associated activities—exhibitions, conferences, visits to private collections. And thirdly, there's the social side—this is where people that share the same tastes and interests meet. For a long time, there was a clear split in the art market, with dealers on one side and auction houses on the other. And the auction houses were the most photogenic. But the big picture gradually changed with the steady progression of Art Basel. Under the direction of Lorenzo Rudolf, it took on the trappings of a cultural phenomenon. Each year, the organizer invented a new event—keeping the whole operation a lucrative one. In 1999, the introduction in the Art Basel catalog was even written by Harald Szeemann, curator of the Venice Biennale. That same year, Rudolf opened an immense exhibition space at the fair, which offered monumental works installed by a curator. "At the time, we understood that our true competition was not another fair, but the Venice Biennale," explains Lorenzo Rudolf today. "In fact, two years earlier, a major American journal had titled an article about Art Basel 'The Real Biennale.' We need to surpass ourselves to follow the trend. The private market, major collectors capable of buying gigantic pieces; and the public market, made up of spectacular things that you can visit, are coming together." In 2000, Rudolf left Basel to join the Frankfurt Book Fair, and after many other projects, in September 2007, he organized a new concept art fair in Shanghai. In Basel, he was replaced by Samuel Keller, who became the powerful and ever-present representative of the fair worldwide. At the end of December 2007, he too will be moving on.

When the top European dealers joined forces to attract the American continent to the Swiss city, they first drew American dealers, then American collectors, followed by professionals and buyers from Japan, Mexico City, and so on, to the point where curators and customers were

coming from around the world. The astounding thing about the whole operation is that today people come to Art Basel—which is basically a sales event—as if it were a cultural one. Now there are not only art buyers, dealers, and visitors, but also art critics, art historians, and the art curious. The fact that works are selected and shown according to purely promotional criteria is completely overlooked by viewers at the fair. Yet in the white cubes—which serve as gallery stands and are bitterly fought over, since they generate turnover and visibility for an entire year—how can one judge the importance of such and such a work in the middle of a mass of others?

In fact, the line separating the commercial aspect of a fair and the noncommercial aspect of a cultural event has been totally erased.

In uneven years, Art Basel takes place right after the Venice Biennale. No matter who the chosen curator is, the Venice Biennale serves as the latest-trend label. So the smart thing is to manage to find the dealer of an artist showing in Venice and buy some works. Often, the game is already over by the time you arrive in Basel. Most of the leading works—the hottest works, as they're often called—are already sold. So paradoxically you can now buy at the Venice Biennale but not at the Art Basel fair. The institutions themselves feed this confusion of genres. In 2007, in order to make art tripping easier for visitors from around the world, several fairs joined together under one hat. These included the Art Basel fair; the Venice Biennale; Documenta, which takes place every five years in Kassel, Germany; and Skulptur Projekte, a sculpture exhibition in Münster, Germany, happening every ten years. This operation was dubbed the Grand Tour, referring to the seventeenth-century European voyage taken by wealthy young men in search of culture on the traces of antiquity. The reference is catchy, but not very fitting. It's difficult to transfer the spirit of a long-ago search for ancient culture to this curious twenty-first-century art shopping trip.

Art Basel experienced a frenzied 2007, the perfect reflection of art market excess. The opening of the show—which gathered three hundred artists, with more than five thousand works of all types—toppled the traditional calm that usually reigns in the Swiss city. The buying public

was all worked up. "It was like the first day of a department store sale," remarked Marwan Hoss, from the Parisian gallery of the same name. For the New York–based broker, Franck Giraud, "the most impressive thing in the present market is the rapidity with which the buyers make their decisions." From the very first hours of the event, the visitor stress level was high. The Sunday before the official opening, a collectors' adviser put on a wig so the fair organizers would not recognize him and went from booth to booth, pretending to be working for a participating gallery. He wanted to do his shopping before the crowd. On Monday, the collectors had passes to visit the two floors of show stands. And by Tuesday morning—the day of the official opening—a number of the artists considered "super-hot" were already sold out.

Take for example, the case of German painter Anselm Reyle. Born in 1970, he was one of the stars at the May 2007 opening of the François Pinault collection in Venice's Palazzo Grassi. In his work he updates the grand classics of twentieth-century abstract painting. He appropriates modern art that has become classic. Reyle is represented by the very influential New York gallery Gavin Brown, and also by a Berlin gallery, one in Glasgow, and the Almine Rech gallery in Paris. This last gallery invited the artist to act as curator at its booth during the Art Basel fair. Reyle chose eight works by various artists along with one by himself. Almine Rech notes that "everything was sold in less than two hours." At that time the gallery was proposing Reyle's works for prices ranging from €20,000 up to €80,000 for a very large format. But today, Anselm Reyle is sought after by buyer-speculators. His work figures among what are considered to be the most important private collections. In 2006, he was given a solo exhibition at the Kunsthalle in Zurich, and that same year he was part of a much-talked-about group show of contemporary art in Los Angeles. All of this has made him more than credible in the eyes of potential buyers. Which explains why at a Phillips auction last May in New York, a bidder shot all the way up to $192,000 to obtain one of Reyle's paintings. It had been estimated at $25,000. Just thirteen months earlier, the record price for the

artist's work at auction was only $19,000. During the Basel fair, the gallery admitted that it was worried about the trend for speculation on the artist's current production.

A more classic case is that of New York's L&M gallery. On May 15, 2007, pop artist Tom Wesselmann's *Smoker #17*, a 1975 painting depicting a woman's pulpous, oversize mouth, brought a record hammer price of $5.8 million at auction in New York. The L&M gallery and its codirector Dominique Levy were quick to react. Shortly after, at Art Basel they proposed a Wesselmann painting from the series "Great American Nude," showing a young naked woman with a cigarette in her mouth. The asking price was $4 million. "Six months ago, we would have estimated the painting at $3 million, but auction results have confirmed higher prices." During the fair, Eli Broad, cofounder of Kaufman & Broad, and one of the most famous collectors in the United States, commented, "Prices are crazy. But I'm a collector. I can't stop myself from buying. During the last May auctions in New York, I acquired a painting by Lichtenstein and another by Agnes Martin."

In the November 2006 issue of the American women's magazine *W,* which was devoted to contemporary art, the editorial put the art fair in a social context: "You don't need to look any further than the landing strip of Miami the first week of December—when private jets bring collectors from Midtown Manhattan to Art Basel Miami Beach—to know that contemporary art is hot.

Art fairs, which were a response to the new habits of twentieth- and twenty-first century art buyers, have become victims of their success. In 2007 at Maastricht, the same amount of space—25 percent of the exhibition—was allotted to twentieth-century art as to older art. "We can't distance ourselves from the new market trends," justified Titia Vellenga, the fair's marketing director.

At the same time, to thin out unwanted visitors who might go through the stands without buying, the fair's 2007 ticket entry price rose to $80. At any rate, the big spenders are always invited. During the 2006 Art Basel Miami Beach, there were no fewer than twelve peripheral fairs. Who could possibly hope to visit them all, or want to see

everything? But fairs have become the main forums for the art market, and the model is being copied worldwide at an infernal pace. From Rome to Mexico City, Dubai to Saint Sebastian, Shanghai to Abu Dhabi...Regional fairs and specialized fairs dream of growing into major ones. The map is overcrowded with newborn fairs. Gérard Goodrow, head of Art Cologne, realizes that this overabundant offer is "bad for collectors who no longer know where to go." According to him, in the long term only three fairs will be necessary stops in Europe. But which ones?

The FIAC in Paris is fighting to get back international recognition after several years of being overly Franco-French, while the London art market is flourishing since the invention of the Frieze Art Fair in 2003. Its original identity was young, euphoric, and rock 'n' roll. But it soon caught the international art market mood. In 2006, there was less rock 'n' roll and more big money and major players. Ben Brown, a former Sotheby's contemporary art expert, now a gallery owner on Cork Street, is clear, "Today, London is the only fiscal paradise—for foreigners—that is a truly pleasant place to live. Also, many people—French, Russian, Chinese, Indian—have bought large houses here and need to cover their walls. It's a parking lot for the money of the world's richest people, who inevitably have an influence on the art market." This population of high-end exiles may not always be a population of aesthetes. On the other hand, they have a basic instinct about what will resell with added value. Ben Brown remarks, "A Damien Hirst painting that you paid 100 for and obtained 150 for a few months later at Christie's is the perfect example to seduce this sort of clientele." London, and by extension its fair, has become a new site of artistic globalization.

In his article, "L'Homme, l'objet et la chose,"[7] the sociologist Jean Poirier speaks about our consumer rituals and the "importance given to the interchangeability of ordinary objects and on the other hand, the appearance of this element that would have caused a scandal only half a century ago: the disposable object." He goes on, "In many cases one might think that economic ostentation is a technique...aimed at bringing into the norm of the group any person that has a tendency to draw

away…The ostentatious economy is a sacrificial economy that ought to be interpreted in ethnological terms."

The art market is just that—a place of total economic ostentation. To take up Jean Poirier's idea, this profusion of art fairs is a way of bringing the wandering sheep back into the fold, the family, and the small circle of worldwide consumers of today's creations. At the same time, the multiplication of offers from New York to Miami, from Paris to London, from Maastricht to Brussels, and from Cologne to Mexico City is tied to the notion that art is quickly outmoded, thus interchangeable, even disposable because of its lack of relevance to its time. But at any rate it can be quickly replaced by new acquisitions.

So what does this circle of collectors do when they meet so often and energetically at these bazaars of the twenty-first-century art business? They buy. However—and this is the real revolution of 2006–2007—they also sell. A lot. Added value is so significant in today's art market that all, or almost all, of the major contemporary art collectors also do business. The temptation is too great. They no longer need an auction house to sell off all of their Warhols or Basquiats. They sell for the fun of it, for the taste of money. To buy more young artists who will become more expensive and will sell for more and still more. I sell, you sell. I exist and I profit from the newcomers, the new rich art lovers, great in number and ready to buy art.

1. There have been occasions when the bidder simply competes with the reserve price—the price set by the seller in agreement with the auction house, below which the object will not be sold.
2. A guarantee means that whatever the outcome of the auction sale, a predetermined minimum sum will be paid by the auction house to the seller.
3. Ambroise Vollard, *Souvenirs d'un marchand de tableaux* (Paris: Albin Michel, 2005).
4. Robert Rosenblum, "The Demoiselles d'Avignon Revisited." Art News, April 4, 1973.
5. The press release, dated November 12, 1997, stated that "While we achieved solid prices for some of the paintings, we were disappointed in the failure of five paintings, including Modigliani's *Nu couché aux bras levés*, to sell. Nevertheless, there was considerable interest in several of those paintings immediately following the sale, and we are hopeful we will be able to sell them shortly." A few months later, the canvas was on show at the booth of the English dealer Helly Nahmad at the Paris international art fair, the FIAC.
6. Anne Martin-Fugier, *La Vie d'artiste au XIXe siècle* (Paris: L. Audibert, 2007).
7. *Histoire des moeurs*, edited by Jean Poirier, "Encyclopédie de la Pléiade" (Paris: Gallimard, 1990).

"Humor upsets people like a form of moral anarchism by attacking serious matters."

GASTON DE PAWLOWSKI

The Artist
and the price

On its own, this section could easily run to book length. These few lines only begin to consider the artist's influence, but in an area where least expected: prices.

The Gensollens, who live in Marseille, France, and collect conceptual art with great seriousness, recount this very revealing anecdote: "It was at a big sculpture exhibition in the 1990s, in Münster, Germany. The Italian artist Maurizio Cattelan, who wasn't so well known then, had decided to create a piece that consisted of a female dummy weighed down with cement, which was going to be thrown into the local river. All over the town, people kept seeing the woman in the water. They looked down from the bridges at the water and shouted out whenever they saw a form there. And yet, the piece had been taken out of the river at the last minute because of a petition." Marc and Josée Gensollen very much liked this idea of an imaginary piece that was seen everywhere, and even ended up buying it. Contemporary art is a bit like this work by Maurizio Cattelan. Everyone has their own way of imagining it, based on their own fantasies, but perhaps it is not what they thought it is. That is the problem with contemporary art. It is relevant insofar as it escapes the strict rules of painting, sculpture, and photography as they prevailed in the past. It thus takes paths that have no rules, where the principle of valorization is not or is only very slightly, based on art history.

A. THE PRICE OF IMMATERIAL ART

In the past, artists had always created for the glory of God. However, once artwork was deprived of its spiritual pretext, it became involved in a permanent quest for new references. Seeking beauty, the grandiose, the emotional, the surprising idea, transgression. Why make art? In the end, with the absence of God as the source of inspiration came making art for art's sake. But for many art lovers, and therefore, buyers, "art for art's sake" is not an adequate reason. That is where money comes into play. To make art for money, or rather, against money, is to provide a tangible criterion of value, a benchmark. It is to make art accessible to man so that man can take himself for God.

According to experts, the first steps in the secularization of art were taken during the French Revolution. Paintings, sculptures and churches were separated from their original, sacred role and became works that were simply—if sublimely—aesthetic. Much later, in *Lectures on Aesthetics* (1828), Georg Wilhelm Friedrich Hegel foresaw the importance that artists themselves would soon attribute to the idea of art: "Art is, and remains for us, on the side of its highest destiny, a thing of the past. Herein it has further lost for us its genuine truth and life, and rather is transferred into our *ideas*...Therefore the *science* of art is a much more pressing need in our day than in times in which art, simply as art, was enough to furnish a full satisfaction...Art invites us to consideration of it by means of thought, not to the end of stimulating art production, but in order to ascertain scientifically what art is." In an age when artists no longer have the simple objective of making something beautiful to the glory of God or to earthly royalty, artists make a considerable contribution to the philosophical recognition of the nature of art. In the chaos of art, each man gives his own answer.

When asked if it was possible to make works that are not 'art,' Marcel Duchamp answered affirmatively. Such equivocal wording left the door open to all kinds of visual vagabondage, but also to all the peregrinations of the market. A little later, in 1957, the visionary Yves Klein, a French artist who died in 1962 and became famous for his

monochromes in a color now known as International Klein Blue, clearly demonstrated the consequences: the dematerialization of the work of art and the relativity of its price. The following text, taken from his personal archives, is a gem for anyone intrigued by the relation between art and money:

"For my second exhibition in Paris, at Colette Allendy in 1956, I presented a choice of different colors and formats. What I wanted from the public was that 'minute of truth' evoked by Pierre Restany in his preface to my exhibition, making it possible to do away with every kind of external contamination and attain that degree of contemplation where color becomes full and pure sensibility. Unfortunately, during the events organized on this occasion, and notably at a debate organized at the Colette Allendy gallery, I realized that many members of the public, enslaved by visual habit, were much more responsive to the relations between the different propositions (relations between colors, levels, values, dimensions and architectural elements): they reassembled them as the elements of a polychromatic decoration. This is what led me to go further in my attempt and to present, this time in Italy, at the Apollinaire Gallery in Milan, an exhibition devoted to what I dared to call my Blue period. (I had in effect spent the last year or more researching the most perfect expression of 'Blue'.)

"This exhibition was made up of some ten paintings in deep ultramarine blue, all strictly identical in tone, value, proportions, and dimensions. The rather passionate controversies provoked by this exhibition proved to me the value of the phenomenon and the real depth of the upheavals that it induces in men of goodwill, who have little interest in submitting passively to the sclerosis of recognized concepts and established rules. I am happy, in spite of all my mistakes and naiveté and the utopias I live

in, to be researching such a contemporary problem. The most sensational thing I observed was the 'buyers.' Each chose his own work from the eleven paintings exhibited, and each paid the price that was asked. The prices were all different, of course. This fact proves, for one thing, that the pictorial quality of each painting was perceived through something other than its material and physical appearance, and for another, that those who were doing the choosing recognize the state that I call 'pictorial sensibility.' Ultimately, the physical painting owes its right to exist to the sole fact that we believe only what we see while obscurely feeling the essential presence of something else, something of much greater importance. And so I am looking for the real value of the painting, that which explains the fact that two works that are, in all their visible and legible aspects, such as line, color, drawing, forms, format, thickness of paint and technique in general, strictly identical, except that one is painted by 'a painter' and the other by a skilled 'technician,' a craftsman—though both are officially recognized as 'painters' by the community: It is this real, invisible value that makes one of the objects a 'painting' and the other not. In fact, what I am trying to achieve, my future development, my way out through the solution of my problem, is not to do anything anymore, as soon as I can, but consciously, with circumspection and due precautions. I am trying to *be*, period. I will be a painter; people will say, 'He is a painter.' And I will feel like a painter, a real one, precisely because I don't paint. The fact that I 'exist' as a painter will be the most 'remarkable' pictorial work of the age."

How can two identical works of art fetch different prices? Such is the magic of the artist, or the absurdity of the commercial system.

B. THE ARTIST MYTH

In the art market as we know it today, the work of an artist can also be read in the light of the myth with which he can be associated. His experiments may be failures or the result of existential unease, but it is often enough, simply, that he should embody a myth, a story worthy of a novel. The great champion in this genre, the champion in spite of himself in every category, is Vincent Van Gogh. Madness, severed ear, unlucky in love, commercial failure—Vincent suffered, and that counts in his favor. It would not be surprising if the high priests of the artist cult replaced Christ's words, "for this is my body," with, "for this is my canvas." Neil MacGregor, director of the National Gallery in London, explains this phenomenon very well when he discusses Van Gogh's masterpiece *Sunflowers*.[1]

> "We know that for Van Gogh this piece must have been an expression of pleasure and joy. He made it to celebrate Gauguin's arrival in Provence, to demonstrate the happiness he felt at the coming of his friend. But we are so obsessed with the artist's personality, with Van Gogh's anguish, that we are determined to see in this painting, as we do in all Van Gogh's paintings, traces, signs of the anguish he suffered. And this phenomenon appeared very early on, as people wanted to see Van Gogh as the archetype of the isolated and ignored artist who had to suffer to produce the works that move us so deeply. It's a quasi-religious vision of the artist. This painting seems to become the personal expression of Van Gogh's suffering. When [the painting] was reproduced in Japan in 1912, a Japanese critic spoke about it in a very surprising way: 'If, when Van Gogh was painting, someone had measured the flow of the blood in his veins, it is likely that they would have found the same undulations as we find in the painting.' In other words, the painter's blood was transformed into paint on the

canvas. The painting becomes not only a sign of the artist's redemptive suffering, but also, to a certain extent, a relic of that suffering. And I think this is where we need to look if we want to understand why the public reacts so violently when the question of changing the attribution of a painting arises. The value of the painting is of course not just aesthetic; it is a relic, whose authenticity justifies the artist's suffering and by its presence allows us to share it."

A relic of the artist god. Can it be a coincidence that the first price-busting record on the impressionist market was recorded on March 30, 1987, at Christie's London, when a certain Mr. Yasuda, head of a Japanese insurance company, bought Van Gogh's *Sunflowers* for nearly $40 million? Up till then, prices for the most sought-after works were in the region of $10 million. Who knows, perhaps when he took those first steps into the gravity-free sphere of hyperbidding, Mr. Yasuda was unconsciously motivated by his fellow countryman's analysis.

If the life of an artist can be manipulated or talked up for commercial ends, then the artist himself can also construct his own myth, his own "product marketing." For the art consultant Diego Cortez, who has the merit of frankness, "A whole generation of artists has grown up that is incapable and quite indifferent to the idea of making good art. All they want is to be successful."

The pioneer in the exercise of self-promotion, the king of personal marketing—who may have been inspired by Dalí—was Warhol, who, while he certainly had talent, was also guided by a desire for fame. "I want to be Matisse," he declared in 1956. Perhaps the American artist really did want to be Matisse, but he certainly did not want to paint like him. The pope of pop art was fully aware of the public appetite for the artist myth. He also created a persona that probably had very little in common with his true nature.

The general public knows about his social life; the company he kept; his underground connections and all the accompanying scandals,

drugs, alcohol, and sex; and also about his fascination with celebrities of all kinds. And, of course, they have seen some of his best-known canvases. But Warhol is remembered mainly because of the character he cobbled together. Always offbeat, with his strange physique and that white, stiff wig that made him look like an extraterrestrial. Whereas the way he really worked as an artist remains shrouded in mystery. Warhol himself used to say, "If you want to know all about Andy Warhol, just look at the surfaces of my paintings and films and me, and there I am. There's nothing behind it." Nothing, really? Warhol was born into a modest immigrant family in Pittsburgh, and it was by no means easy for him to make it in the world of advertising in New York. At the time, the 1950s, he was an illustrator living in a cockroach-infested, crumbling building. As he later said: "I'll never forget the humiliation of bringing my portfolio up to Carmel Snow's office at *Harper's Bazaar* and unzipping it only to have a roach crawl out and down the leg of the table. She felt so sorry for me that she gave me a job." The young Andy had a huge appetite for social recognition. The catalog to the Series and Singles exhibition at the Beyeler Foundation, Basel, in 2000, mentions the fact that he would stop off in a church several times a week in order to pray for success in the art world.[2]

But how to be the Matisse of 1960s America? By chronicling the spectacle of mass consumption, showbiz, and the star system. Warhol was the first artist of the pop generation to understand the omnipotence of the media. And he created his own myth by conjoining it with preexisting myths. He took the new American idols for his models. The best known of these is certainly Marilyn. Marilyn Monroe fascinated the whole population, from housewives to John Fitzgerald Kennedy. In 1964 the painter bought a photo from Niagara and used it to produce a series of twenty-three canvases using a new technique that combined painting and silkscreen printing. Fame is a mainspring of Warhol's art. Just as, he argued, it is in society: "Nowadays if you're a crook, you're still considered upthere. You can write books, go on TV, give interviews—you're a big celebrity and nobody even looks down on you because you're a

crook. You're still really up there. This is because more than anything people just want stars."

In 1968, Warhol was the victim of his own renown. He was grievously wounded by a bullet fired at him by one Valerie Solanas. A few years later he stated that "I wish I'd died. I would have become someone out of the ordinary." He eventually lost his life in 1987 during a surgical operation. Not a very romantic death, and not the kind that is remembered. But the master of the Factory is without a doubt considered out of the ordinary. And his prices are on a par with his image. According to the Artprice database, in the year 2000 some seventy-seven Warhol paintings were sold at auctions around the world for a total of $29.6 million. In 2006, 1,010 paintings changed hands for a total of $199.3 million. In six years, the number of deals had grown exponentially.

C. TO BE OR NOT TO BE A (PROFESSIONAL) PAINTER

In 1915, the great, but nevertheless nonchalant, Marcel Duchamp wrote to an American painter and writer, "I do not wish to glimpse the life of an artist seeking glory and money. I am very happy when I learn that you have sold those canvases for me, and I thank you very sincerely for your friendship. But I am frightened of reaching a point when I need to sell canvases, of becoming, in a word, a professional painter."[3]

Duchamp explained how he escaped from the system of buying and selling in an interview from 1913. "It was a really important moment in my life," he said. "I had to make big decisions then. The hardest was when I told myself, 'Marcel, no more painting, go get a job.' And I looked for a job in order to get enough time to paint for myself. I found a job as a librarian in Paris in the Bibliothèque St. Geneviève. It was a wonderful job because I had so many hours to myself.

"And that led me to the conclusion that you either are a professional painter or not. There are two kinds of artists: the artist that deals with society, is integrated into society; and the other artist, the completely freelance artist who has no obligations and therefore no constraints. The danger is in pleasing an immediate public; the immediate public

that comes around you and takes you in and accepts you and gives you success and everything. Instead of that, you should wait for fifty years or a hundred years for your true public. That is the only public that interests me."

Nowadays, many artists inspired by Duchamp's conceptual approach and by his use of what he called the readymade are nevertheless "professional painters" in the sense meant by Duchamp himself. This was sometimes true of Andy Warhol, for all his ambiguous desire to shock. He once said, with a real sense of provocation, "I like money on the wall. Say you were going to buy a $200,000 painting. I think you should take that money, tie it up, and hang it on the wall. Then when someone visited you the first thing they would see is the money on the wall." Obviously, in consumer society, if you want art to be a license to print money, then you had better mass-produce the stuff. As of 1962, Warhol made systematic use of the same approach to painting: repetition via the process of silk-screen printing. He had found a personal language that would enable him to live on in posterity. "The reason I'm painting this way is that I want to be a machine, and I feel that whatever I do and do machine-like is what I want to do," he explained. "To make a silk screen, you take a photo, blow it up, transfer it onto silk using a layer of gelatin, then put color on it. The color goes through the silk but not the gelatin. So you get an image that is always the same but always slightly different. It's so simple, so quick, and with an element of chance. I loved it."

Warhol had the ground of the canvas painted and, after the printing, would sometimes add a few extra touches of color. It was thus possible to print several identical images on the same canvas and to print an infinite number of canvases, which would vary in terms of color, the number of times the motif repeated, and the format. Here the idea of the series goes hand in hand with that of the unique artwork.

Paradoxically, the strongest selling pitch for collectors when it comes to Warhol paintings nowadays is rarity. How many pieces did he produce in such-and-such a format on such-and-such a theme? The problem is that our knowledge of the different types of work made by

Warhol is not exhaustive. The catalogue raisonné of his paintings is still incomplete. Other contemporary modes of expression are calling into question the materiality of art in a more subtle way. Most of the time these are photographic images. They are the worthy heirs of the precepts established by Warhol. This principle applies to so-called art photography, which comes close to painting in its use of large formats and limited editions—three or six prints, say: just enough to put the prices up and make the neighbors want one when they see them in the sales catalog. In this case, the force pushing up prices is not the possession of something that no one else can own but the desire to be a part of an exclusive group. A combination of exclusivity and association forms the new headiness of the limited edition. Some art lovers have moved beyond wanting a unique work. They want what the person they envy or the institution they admire already possesses. Current photography is an ideal instrument for this form of social competition.

This may well be the logic behind a string of new records. At the end of 2006, according to the Artprice database, the record for a contemporary photograph was held by a two-part work (printed in an edition of six) by the German Andreas Gursky, dating from 2001. It was sold by Phillips for $2.2 million. Titled *99 Cent*, it consists of a panoramic view across the shelves of a single-price (99 cent) supermarket. The effect is extravagant, the power of the image utterly effective. One of the two prints is 132" long, the other, 51" long. Born in 1955, Gursky is an artist who does only photography. By 2001, he was given the honor of a retrospective at the Museum of Modern Art in New York.

Gursky has solid gallery support. In New York he is represented by the very active Matthew Marks. In Zurich, he has Galerie Mai 36, and in Cologne, Galerie Monica Sprüth. His network of valorization is solidly established, and the first recipients of each piece from the editions of six sold by the galleries were certainly chosen with great care. After all, the limited edition printing of a photograph is nothing other than a strategy for bringing this medium closer to painting, which is unique by nature. The current market, dodging the issue and at the same time burying its head in the sand, would have us believe that a

video or photo work can be unique, which is why quantities are limited and works numbered and signed. In 1936, Walter Benjamin dismissed the obsession with the original as a form of bourgeois fetishism. Even after the coming of Andy Warhol and his theories, and in the age of the hyperreproducibility of the artwork, the market is still tied to classical principles of value, such as dimensions and the number of copies in circulation.

For the French sociologist Jean Baudrillard, the step taken by Warhol in his approach to production was a crucial one, for it expresses the fact that our society fetishizes value even more than it does the actual artwork: "It is Warhol who went furthest in the nullification of the subject of art, that of the artist, and in the devaluation of the creative act. Behind this machine snobbery, what was really happening was the rise of the object, of the sign, of the image, of the simulacrum of value, the finest example of which we now have is the art market itself. Here we have moved far beyond the alienation of prices, which are still a real measure of things: we are in value fetishism; which is exploding the very idea of the market and, at the same time, annulling the work of art as such." And the more dematerialized the work, the more effectively this "value fetishism" can express itself.

In other words, it is all about selling an idea. Cashing in on an idea is a bit like selling wind or a written, illustrated, or whatever trace of that idea on paper or on a canvas or in a space. But at the end of the day, the most tangible trace of this concept that the artist has put in place will be that of the dollars, euros, or other currency for which it is exchanged.

In a book about first works, Maurizio Cattelan (born in 1960) says that up to the age of twenty he lived in a small town in Corsica, a setting that profoundly affected him. "I was somewhat of a loner and I used to play with what was around me—the clouds and the sea...I really did spend a lot of time just observing the sea, the repetition of the waves, the simple rhythms through which nature is formed. It was particularly important because it forced me to find the motivation for work in the 'simplest' of things."[4]

Cattelan is one of those artists who works with the intangible. Or not. He once said, "I don't benefit from the prices in auctions. The prices in galleries are much lower." The record price for his work is $3 million, and it was paid for an installation representing the Pope struck down by a meteorite. This top sum dates from 2004. When the work was first put up for sale it fetched $886,000.

But where Cattelan is at his most disconcerting—and no doubt his most incisive, too—is in work that really does play games with the market. In 2001, he opened The Wrong Gallery in Chelsea, New York's thriving gallery district, in collaboration with the independent curators Massimiliano Gioni and Ali Subotnick. This tiny space comprises a single display case of ten square feet. There is no door. It housed six exhibitions a year in this location until July 2005, when, as a result of real estate problems, The Wrong Gallery moved to Tate Modern in London, which has agreed to house the project until December 21, 2009. The slogan of this microspace, endowing it with metaphorical significance, is typical of Cattelan's pranksterish spirit: "The Wrong Gallery is the back door to contemporary art, and it is always locked."

Often, Cattelan gets his friend Max Gioni to do the talking for him in interviews. About The Wrong Gallery, Gioni remarks that "We haven't written anything systematic or precise on the subject. What's it about? It's a way of having fun, of doing things that we wouldn't be able to do elsewhere, and especially, of keeping alive the sensation that you can do things with virtually nothing, providing it's all based on the enthusiasm and help of people who are interested. And business at The Wrong Gallery...Well, that's the best part. There isn't any business. There is no money, no buying or selling. Which means that we've got it all wrong. It really is a small, tiny little space of freedom. Or, as we always say, simply the back door of the art world. And it is always locked." But when he concludes, he sounds as proud as any full-time gallery director: "Since we moved to Tate Modern in London, we have been the only gallery inside a museum."

Another figure in the "agitator" category is David Hammons. Born in 1943, this African-American is a kind of will-o'-the-wisp of the art

market, an elusive but talented character who has no gallery and avoids the most institutional aspect of the art world. When invited to take part in the Biennial at the Whitney Museum of American Art in 2006, he responded by exhibiting the work of another African-American artist instead of his own.

But while Hammons seems to decline major museum shows, his work did appear in the Italian Pavilion at the 2005 Venice Biennale. The famous French collector François Pinault also owns a number of his pieces, which have been shown in the first two exhibitions of Pinault's collection at the Palazzo Grassi in Venice. His most recent show in New York was at L&M in March 2007. In this big space on the tony Upper East Side, Hammons chose to show an ensemble of fur coats hung on wooden mannequins. Seen from the back, the coats turned out to be soiled, cropped, or daubed with paint. According to the gallery, this was a homage to artists such as Jackson Pollock, Julian Schnabel, and Yves Klein—all the genres. But it was hard not to think more in terms of social critique when you saw these costly furs damaged and displayed in the heart of moneyed New York. The real interest in the show developed when the artist himself offered no clues about the works. Were they for sale or not? A series? Unique pieces or multiples? And how much? Nobody at L&M could say. A few days after the "show" closed, Dominique Levy, codirector of the space, commented: "His work is very hot. But you know, three days before the exhibition, I still didn't know what I was going to show. As for him, I would say that his goal seems to be to try to slow the world down a bit. When you tell people there's definitely nothing for sale, there's no pressure." And the result? "Everything was sold at once. The price for a single work? Between $3 and $3.5 million. Why here? Because he wanted to exhibit where Klein and de Kooning had once been shown."

In May 2007, during the latest exhibition by Japanese artist Takashi Murakami in New York at Gagosian Gallery in New York, the big canvases sporting giant faces of a Buddhist sage in a variety of shades were officially sold for $1.6 million shortly after the private view. Born in 1963, Murakami also wants to be a player on the art market. Carol Vogel

of *The New York Times* calls him the "Warhol of Japan." This Gagosian show was Murakami's first with that gallery after ten years with Marianne Boesky. "I am always looking for new ways of making art," he said. And, very unexpectedly, continued: "And everyone knows Larry [Gagosian]. When he asked me, it was good timing."

Murakami considers his place in the art market with care and recognizes what he feels is a responsibility to other artists. His New York and Tokyo–based company, Kaikai Kiki, organizes events, produces objects, and promotes other artists. Its Web site clearly states its mission. "Art is the supreme incarnation of luxury entertainment…In the management of our artists, we maintain policies and standards for their dealings in the art world, while also keeping flexible and considering projects case-by-case, all with the careers of our artists in mind. While it is an idealistic vision, this insistence on the highest standards of quality and communication is a driving force in my work."

Thus, the idealism of the artist Murakami is expressed in the fields of communication and promotion. Twice a year, he organizes Geisai, a daylong art fair that, since 2001, has brought together hundreds of artists with no preliminary selection. "Kaikai Kiki is a pioneering organization looking to the future to broaden the horizons and parameters of contemporary art." The figures churned out by Murakami may come from a cute world in which manga characters are depicted in bright candy tones and the flowers all have eyes and a mouth, but the discourse is very serious. Unlike Cattelan, for example, this boy doesn't just want to have fun. Murakami is the general in charge of defending a Japanese art market that is under construction, as the Kaikai Kiki Web site tells us: "Over the years, I have encountered many hurdles in my path. But in clearing them, I have taken each challenge as an opportunity to expand my dreams and goals. One such hurdle was that in postwar Japan, there was no reliable art market. The art scene existed only as a shallow appropriation of Western trends…unable to support an artist's career over many years. I realized this when I was a student and stopped operating within the Japanese art market altogether, investing my energies instead into promoting my works overseas. Now that I

have seen the results of that endeavor, I am returning to the Japanese market in an attempt to build what was not there originally. The art fair that I organize in Tokyo two times a year, Geisai, is the product of this new attempt to spur the Japanese art market." The latest news is that Murakami is planning to set up a Geisai in Miami.

Wim Delvoye (born in 1965) is a successful Belgian artist who figures prominently in many European collections. In spring 2007, the Zurich-based gallery de Pury & Luxembourg sold a bronze sculpture evoking medieval art for $800,000 (it was an anamorphosis representing a crucifixion). This is the highest sum yet reached by Delvoye, whose protean output includes the highly complex machines designed to mimic human digestion and produce excrement. These machines are called *Cloaca*, from the Latin word for sewer (a neat allegory of our society). His output also includes the tattooing of live pigs raised for him on a farm in China, which he later sells as artworks once they have been slaughtered and stuffed or skinned. Delvoye is well-known for his candor. "I am like other artists, I have an ambivalent relation to the art market. When a piece turns up at auction, you wonder if it got there because the collector doesn't like it anymore. It's like a refusenik, a banished object. But at the same time, you want it to fetch a big price. Today, the tendency is to see a dichotomy, with the market on one side and the academic world on the other. But if there was once an opposition, I would say that the market has now won the battle. Curators and critics are on their knees before the market. In the United States, in Germany, young artists you have never heard of sell for more than a veteran like Julian Schnabel. The way I see it with prices is that things should rise gradually, like at the stock exchange. I don't want to be an e-business commodity but a solid company. Being very expensive when you're young is like being alive among the dead. Me, I'm forty-two."

That said, Delvoye is already rubbing his hands with glee at the idea of his next media coup. Auctioneer Simon de Pury will auction the tattooed skin of a living human being. Of course, the tattoo/artwork will be available only after the death of its "support," a gas station attendant

by the name of Tim. Says Delvoye, "A pig is €200,000. Tim, he'll be worth at least two pigs. He is tattooed down his back all the way to the tops of his thighs, and I would like to do the arms, too. It is the ultimate in conceptual art. I want to surprise people, to ask questions about the relation between life and art. The piece is perhaps a way of showing that art is dead. We need to sell for a lot of money." The date of this sale had yet to be set at the time of writing.

A lot of money. Manifestly, this notion is of capital importance to an English artist with an obvious talent for business, Damien Hirst. He, too, was born in 1965 and is usually presented as a very rich man. From year to year and from month to month, his works keep reaching new highs. The most recent was in June 2007, in London: $19.2 million. It was, as we have seen, an auction record for a living artist.

Hirst, the veteran young British artist, is also king of the other part of the market, the world of the galleries and their rocketing prices. In his hometown of London alone there are four galleries showing his work. On June 1, 2007, he chose to exhibit his new piece to the press at one of these, the White Cube Gallery. This is a work of every extreme: a cast of a human skull made from platinum and inlaid with diamonds throughout. One of the most amusing myths that has grown up around this object is that the market price for fine diamonds began to rise as the piece, which uses such large quantities of them, was being conceived. The making of it was entrusted to the jeweler Bentley & Skinner, who also supplies the queen. The cost of making this vanitas, the press was told, was $29 million. And its sale price: $100 million. I hardly need add that no work of contemporary art has ever sold for as much. And nor, to date, is there any solid proof that this one has.

Hirst's press conference also provided him with the chance to give a few interviews. The most revealing one can be found on the Artnet Web site, written by the English e-zine's market specialist, Joe La Placa, who took a levelheaded approach:

JLP: For *The Love of God* has a huge sale price of $100 million...

DH: It's too cheap! People really want it.

JLP: £50 million is too cheap?

DH: Definitely! If the Crown Jewels were on the market, they'd sell for a hell of a lot more than that. It's just one of those objects.

JLP: Yes, but in relation to what other contemporary art has sold for, this is over the top, particularly for a living artist.

DH: Not really. What do you mean, living artist? That's a bit of a fucking red herring really, isn't it, a living artist? I mean, art lasts for thousands of years…and a human's lifetime is less than a hundred years. There are only a few artists alive, relatively speaking. And the art market is, what, two thousand years old and beyond of artistic activity? You need to forget about the living artist and just talk about art.

When I got into the art world, I consciously wanted to change it. I found it really annoying because it seemed like a kind of club where people would sell cheaply to investors, and they'd make the money. Collectors would take the art off the artists and, because they came in early and they gave the artist a little bit of money, later, when the artwork got resold, it would be the collector who made the big money in the secondary market. And I always thought that was fucking wrong. I'm the artist, the primary market. And I want the money to be in the primary market. I've always said it's like going into Prada and buying a coat for two quid and then selling it next door, a charity shop for two hundred quid. It's totally fucking wrong! Why are they doing it that way round? Art should be expensive the first time around. There shouldn't be all these old boys making loads of money on the secondary market."

There is, then, a whole category of artists—and they are among the most sought after—whose work and even some of their creative drive is bound up with acting on the market. Are they, as Duchamp calls them, "professional painters"? Perhaps contrary to appearances, they do seek to please the public, and in a media-driven society like ours, that can also mean stirring up scandal.

Of course, there is no agreement on the role of the marketplace in art—whether Duchamp or Hirst or some other artist weighs in. In June 2007, John Baldessari initiated his own discourse on the matter at the

Art Basel fair. But what was this Californian artist, born in 1931, doing in the epicenter of global art consumption? This charismatic figure, with his white beard and renowned critical spirit, has inspired a generation of Californian artists, and he had come to give a talk. In the lobby of the hotel opposite the fair, Baldessari spontaneously answered questions about the market with nonchalance and generosity. "The art market is absurd. It has nothing to do with art itself. Take my case: Today, my works are worth a lot of money. Before, they weren't worth a thing. But I am the same person. I do the same things. When my sister buys brand-name clothing she says, 'I am buying taste.' In some cases, art is the price on the ticket. And, by the same logic, in Basel I heard a collector saying that if a piece by a young artist cost only $30,000 then that meant it couldn't be good. People use money to reassure themselves."

The market is gradually waking up to the virtues of this great artist. According to Artprice, in 2006 the proceeds from sales of works by Baldessari worldwide were $3.2 million. In May 2007, a single canvas of his from 1967–1968 was sold at Christie's for $4.4 million, more than the total for the eighteen works sold the year before.

The work in question was an ironic commentary on what is considered—by the art market—to be a good work of art. On the white canvas Baldessari had painted the words "Quality material. Careful inspection, good workmanship. All combined in an effort to give you a perfect painting." Historical irony can pay, and quite well ($4.4 million).

That ironic spirit can take us further along the trail blazed by Marcel Duchamp. Tino Sehgal was born in London in 1973 and lives in Berlin. He devises performances that bring collectors and actors into play. He plans each performance precisely. When Sehgal represented Germany at the 2005 Venice Biennale, for example, he organized a large-scale performance called *This Is So Contemporary*, in which actors would stand in the middle of the space and proclaim the words of the title in what was an ironic commentary on today's art, made at the heart of that global artfest that is the Biennale. But Sehgal also works to demand from private collectors. In 2004, for example, a discerning Parisian collector,

Jacques Salomon, chose one of Sehgal's three "Multiples." These are performances that the artist sells in editions of ten. The idea is to choose a headline from that day's newspaper and then, later in the day, repeat it aloud twice in contexts—a discussion, say—that have nothing to do with the subject of the article. For Salomon, the interest of all this is that it "elicits a reaction from one's interlocutor. Tino Sehgal transmits an attitude."

For Ghislain Mollet-Viéville, a Parisian art agent who specializes in conceptual art, "the form of transmission that the artist has set up for his works is of more interest for art history than the work that results, that is, the performance." This is indeed what gives Sehgal's pieces their power. There can be no material trace of the sale of the performance, nor can photographs or even notes be taken of the performance. The artist gives his instructions orally. He accepts payment only in cash, and the client is not given a receipt. The transaction can, however, be carried out in front of a notary, but again, he or she may not take notes. Many collectors have asked museum curators to witness the exchange of money for verbal instructions. You give money and in exchange you have a memory. Sehgal's dealer, the Brussels gallerist Jan Mot, states, however, that the prices of his works are set in advance, as for any other piece. "They rise in keeping with the artist's status. Today, they are sold for between €12,000 for the smallest ones and €40,000 for the big ones, which are often activated in public space."

The art market will have entered a new phase when a piece by Tino Sehgal is sold at auction, given that there will be nothing to reproduce in the catalog and that the transmission will be effected only verbally. The one concrete detail, perhaps, will be the sound of the auctioneer's hammer.

1. "Chef-d'œuvre, valeur sûre?" in *Qu'est-ce qu'un chef-d'œuvre?*, Paris: Gallimard, 2000.
2. Andy Warhol, *Series and Singles*, ex. cat. Beyeler Foundation, Cologne: DuMont Verlag, 2000.
3. Bernard Marcadé, *Marcel Duchamp*, Paris: Flammarion, 2007.
4. Francesca Richer and Matthew Rosenzweig (eds.), *First Works by 362 Artists, London:* Thames & Hudson, 2006.

Conclusion

As Charles Saatchi likes to point out, these days "the market for contemporary art concerns at best a hundred artists." If that market is thrown into a deep crisis by economic turmoil, this will inevitably lead to a questioning of the rules whereby those artists are valorized. Meaning, perhaps, a change of values, and of system.

Today, in 2007, the situation is exactly the same as when I wrote the first edition of this book (*The Worth of Art*), in 2001. Money still has the upper hand in the marital infighting of the unnatural couple formed by the market and art. Internationally, the art market has become a social activity in its own right in which artistic recognition is meted out not only in accordance with criteria of quality and relevance, but also, and above all, as the result of a rite of passage imposed by legitimizing agents that have nothing to do with art. Expensive art can be good or bad. Cheap art can be execrable or excellent. In art, money is not an instrument of justice. But if we accept this principle, then we must allow that the art market is definitely contributing to the thoroughgoing reassessment of the definition of art. Even further down this road, if insignificant art is sold for enormous sums of money, then that would tend to suggest that money itself is pretty meaningless. And the auction as practiced by Sotheby's or Christie's, which is a thoroughbred scion of capitalism, has thus given birth to a system that makes money absurd.